# Plastics 2

For our dearest Theo

# Plastics 2

## Materials for Inspirational Design

### Chris Lefteri

RotoVision

A RotoVision Book
Published and distributed by RotoVision SA
Route Suisse 9
CH-1295 Mies
Switzerland

RotoVision SA
Sales & Editorial Office
Sheridan House, 114 Western Road
Hove BN3 1DD, UK

Tel: +44 (0)1273 72 72 68
Fax: +44 (0)1273 72 72 69
Email: sales@rotovision.com
www.rotovision.com

10 9 8 7 6 5 4 3 2 1

ISBN 2-940361-06-1

Edited by Chris Middleton
Book design by Fineline Studios
Cover artwork by Daniel Liden
Art direction by Tony Seddon
Photography by Xavier Young

Reprographics in Singapore by
ProVision Pte. Ltd.
Tel: +656 334 7720
Fax: +656 334 7721

Printed and bound in China

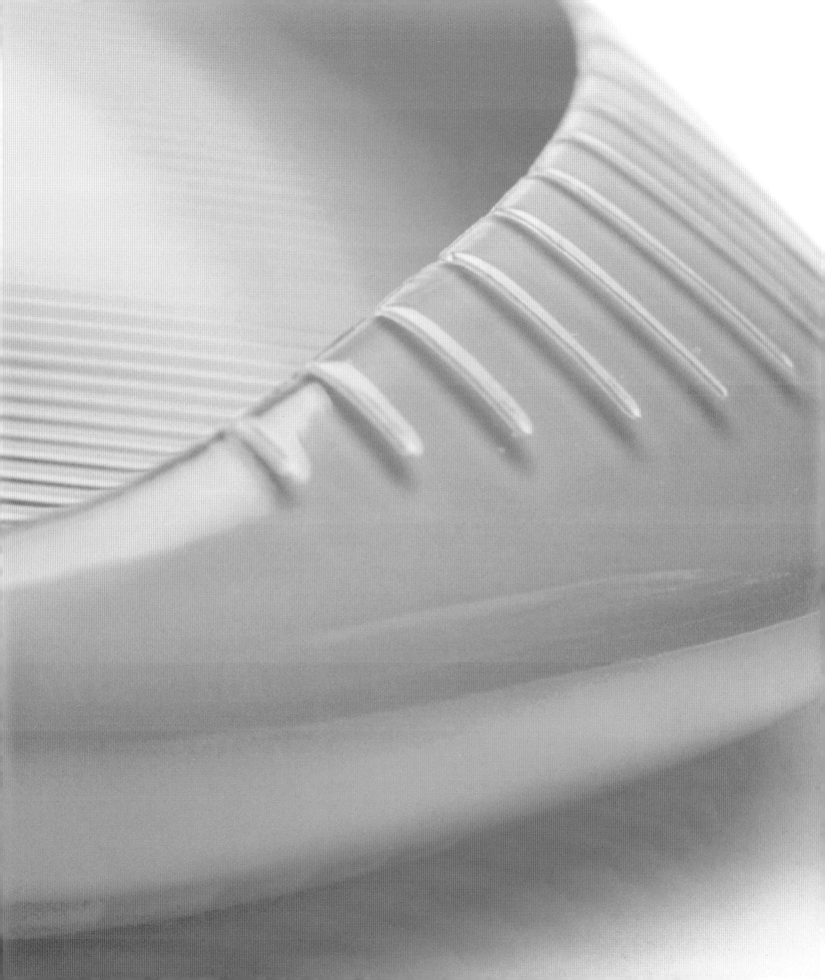

# Contents

Contents

007

# 008

# Foreword

I've loved plastic since I was a child. I can remember the countless objects I had in my bedroom that played a formative role in my life: I treasured an orange, oversized alarm-clock radio by Howard Miller; a light-gray plastic desk fan by Braun; a white plastic Claritone stereo; a Kartell yellow plastic mushroom lamp; a plastic white bed; and a pink plastic chess table. I had the latest plastic blade hockey sticks; a plastic goaltender mask, and a nylon tent, and I would customize my bicycle with all kinds of sparkling, metallic-flaked, rubbery accessories and day-glo details. I was so inspired by these plastic products I painted my bedroom canary yellow, fire orange, hot pink, and white stripes. Plastic was just another material to me, but it was the lively one—the energetic material. It was the glossy one; the smooth one; the transparent one; the glowing one; the soft one. I knew, even at the age of 10, it was the material of our contemporary world.

Plastic has become synonymous with our everyday life, but the word itself doesn't do justice to the literally thousands of diverse types of polymers, from polyester in fabrics and latex in condoms, to polycarbonate lenses, polypropylene car bodies, and about 65 percent of the miscellaneous products and components in hospitals. Plastic is everywhere—in our food, our shampoo, our toothpaste, and even in our bodies in replacement bones and artificial hearts. Plastic is here to stay: we've engineered a fantastic, plastic, polymous, plasticized, malleable, flexible, artificial world.

But what many people don't realize is that the term "plastics" encompasses organic compounds. There are some polymers that contain only the elements carbon and hydrogen, like polypropylene, polybutylene, polystyrene, and polymethylpentene; but various other elements can also be part of the molecular composition: oxygen, chlorine, fluorine, nitrogen, silicon, phosphorous, and sulfur are other elements that are found in polymers' molecular makeup. There are also some polymers that, instead of being carbon-based, have a silicon or phosphorous structure. These inorganic polymers have a liquid, rubbery nature that encourages you to stretch and play with any items that are made from them.

Plastics were invented in the late 1800s. In 1868 an American newspaper offered a $10,000 prize for anyone who could replace ivory billiard balls with a different material. John Wesley Hyatt proposed a concoction called "celluloid" made of nitrocellulose with camphor, and patented it. In 1897, two German chemists, Adolf Spitteler and W. Krische, experimented with casein combining it with formaldehyde to conceive "Parkesine," and in 1909, Dr. Leo Baekeland combined phenol and formaldehyde to create a resinous substance he called Bakelite, a plastic that could be softened by heat and molded into shapes. This inspired organic chemists to carry out more research and plastics were born overnight as a field of science and chemistry.

Polymers allow us to be liberated from the "strictness" of other materials—wood, like marble and stone, for example, is limited by whatever tools are used to cut, process, or work it. Plastic is moldable, pliable, ductile. Something made of plastic can be of any shape, and we can achieve forms unheard of just 100 years ago. We can process plastics in a plethora of ways from foaming it and injection-molding it, to

thermoforming, extruding, casting, and blow-molding it. Plastic has unique, integral properties that neither wood, glass, metal, nor any other materials can match: it can be warm or cold; it can be hard or soft; it can have memory; it can be structural or ultra-lightweight; it can be angstrom-thin or a meter thick; it can be slippery or rough, squishy or as hard as glass. Plastics are the chameleons of materials. Today, we can even make a plastic car engine using thermoset nylon composites.

Smart materials offer another sort of precision and convenience like polymer resins. While we expect material to change due to weathering and age, smart materials anticipate variance—they can mutate into a desired state under certain conditions. For example, thermoplastic mouthpieces for athletes undergo a molecular change when heated. To achieve a perfect fit, you submerge the device in boiling water and then hold it in your mouth for a few minutes while it conforms to the exact contours of your teeth and gums as it cools. In this way, smart plastics can have "shape-memory." They can also change color, heat up, cool down, or conduct electricity, and yet smart material engineering is still only in its infancy. My toothbrush can change color as it ages; my plastic chair can change color due to my body heat; and my plastic rock-climbing rope can change color to warn me that it is wearing out.

Plastics have developed into a very high and innovative level of product. In the furniture industry, for example, there has always been controversy about what was the first all-plastic molded chair, which some people credit to the British (Robin Day's work); the Italians (companies like Gavina, Cassina, and Kartell), and Herman Miller with the Charles Eames molded fiberglass buckets. But it seems to me that the first truly all-plastic molded chair was by James Donahue and Douglas Simpson in Ottawa, Canada, in 1946. Since then, of course, there have been countless prolific plastic

furnishings and products, such as the chairs by Magistretti for Artemide, Gae Aulenti for Kartell, all-plastic bathrooms by Joe Colombo, plastic shelves by Olaf Von Bohr, and all the experiments with plastic furniture over the years by designers such as Verner Panton, Wendell Castell, Mario Bellini, Spiro Zakas, Achilles Castiglioni, Luigi Colani, and so many companies such as Cassina, Plasticorp, Artopex, and Korina. The first plastic thermos drinks flask by Dudas Kuypers Rowan was the most ubiquitous form of democratic design. Plastic also created innovative precedents in the design of, for example, technology-related products, such as the first computer housings by IBM and Olivetti; in the houseware products by Tupperware that brought plastic into the kitchen in the 1930s; the plastic chairs of France's Grosfillex; Bell Northern's plastic telephones in the 1950s; and Braun's products ranging from stereo equipment to kitchen appliances. Today, plastic involves an alchemy of experimentation with great advances in polymer composites—plastics mixed with metals, ceramics, and other aggregates.

In spite of all this innovation and forward-thinking from previous decades, plastic has been been most widely accepted as a material for the home in this century. There still lurks in many minds the antiquated ideas that plastic is for the outdoors when it comes to furniture; that plastic plates are for garden parties and not elegant dining; that plastic is a disposable, "temporary" material—a "lesser" material, in fact, than wood, metal, stone, glass, or ceramics. Yet this book, the second one on plastic in this series, amply demonstrates that we have left behind such banal arguments and that plastic can be luminous, contemporary, rich, pliant, sexy, super-high-performing, and even poetic.

So the next argument that I always find myself having when it comes to plastics is the one concerning conservation of resources, recycling, and the ecology of our planet. Conserving resources means using fewer raw materials and

less energy throughout a product's entire life—from its development and manufacture to its use, reuse, recycling, and disposal. The fact is that this material can conserve more resources during the lifecycle of an object because of the plastics' integral, amazing properties, such as its lightness, durability, and formability compared to other materials. I read recently that despite the fact that plastic plays a role in almost every aspect of our daily lives, its production accounts for only 4 percent of the United States' energy consumption. And even more interesting is the fact that plastics constitute only about 9 percent by weight of all waste generated in the United Status (according to 2005 statistics). In the meantime the real answer to the use of plastic is that we should use less, but better, and the agenda of designers today is to make the best.

I would ague that plastic is now part of our very nature—we can already replace 70 percent of our body parts with plastic. I am a great believer that history is not something to perpetually compare with, or measure, or to be nostalgic for, but instead that an open mind is a contemporary one. The open mind celebrates life and resonates with our momentary experiences. Designers shape this world and the open minded ones see and experiment with the fluidity of plastic. It is the 21st-century supermaterial and one day we will create a plastic replicant of ourselves as the ultimate plastic object: smart, reactive, biogenetic, polymorphous, nanomechanical, technorganic—and perfectly recyclable.

Karim Rashid, 2006

# Introduction

Six years, six books, and untold hundreds of materials later, and the journey that led this industrial designer on his path of discovery into new materials is still only just beginning. The world of plastic, in particular, has continued to grow at a rapid rate—not so much in new formulations, but defiantly in new applications, new technologies, and new composites.

So where is this colossal group of plastic materials moving as it continues to carve its way through every part of our lives? How do we track these new developments, and how do they shift our definition of an industry that continues to evolve so rapidly?

In the broadest terms plastics form a group of materials that is defined by its ability to be easily shaped, but with new composite materials appearing, merging plastics with metals and woods, and infiltrating industries such as glass and ceramics, plastic is not only easily shaped but also a melting pot of crossovers. This is a challenge to how we define plastics in terms of their use, applications, and cultural significance.

What role will plastics have in enhancing values and emotions in our future products, and also in fulfilling the ecological considerations that are becoming ever more important? After all, the world of materials is a diverse place: sometimes it is all about technical details; on other occasions the issues are primarily cultural. Sometimes the debates revolve around global trends and shifts, while in the case of wood and ceramics, they are more usually about local concerns.

For designers, plastic is an infinitely adaptable material, which easily takes on complex shapes —a material with the latent potential to be squeezed, pulled, injected, foamed, and sandwiched. In his seminal book "The Material of Invention," Ezio Manzini talks of materials in transformation. He compares trying to capture a snapshot of materials to taking a group photograph where everyone is in a constant state of movement. This great analogy expresses the difficulty of trying to capture not just the essence of a group of materials that contains thousands of variables, but also how

to record them. From a different perspective Roland Barthes describes plastic thus, "more than a substance, plastic is the very idea of its infinite transformation; as its everyday name indicates, it is ubiquity made visible."

This, my second book of plastics, examines some of the most important research in the field of plastics, and how these are explored in relation to a broad range of products. Within this book there are iconic plastic products, and also materials such as Velcro, a semiformed plastic that lacks the neatness of classification as molding, fixing mechanism, tape, or textile. At either of these two extremes, plastic epitomizes mass production and low cost, while also being a material of "infinite transformation."

But some of the strongest additions to the family of plastic materials are from the area of ecological plastics. Plastics that are not only derived from rapidly renewable sources, but are also biodegradable and compostable. Here the definition of plastics is shifting from being the environmental criminal to a material that comes

from nature and returns to nature. With these new materials manufacturers are, for the first time, having to think about how to unmake the products that they have become so efficient at making. The book illustrates and presents a number of producers internationally who are making biopolymers from agricultural products, such as starch-based vegetables, like corn. One of the biggest markets for these new environmental plastics is in the packaging industry, where the issue of ecofriendly disposal is increasingly a major focus and, for some companies, a brand differentiator.

The ecological issue is also being dealt with from a recycling perspective. The millions of PET bottles that get discarded every day are now being shredded and turned into insulation for ski jackets or carpets, for example. This new area of "reclaimers" is about finding new uses for old materials—not just from retired products, but also from the waste material of other industries, like wood-plastic composites that use sawdust from the conversion of softwood timber combined with a polymer resin to make injection-moldable components.

Also featured in the book is a familiar product of our time, the takeaway coffee-cup lid. In many parts of the world, the coffee house revolution has managed to replace plastic cups with recycled paper ones, but has not found a similar kind of replacement for the millions of lids that end up in the office bin. It is such everyday items that present the biggest problem for the image and definition of plastic.

More than any other material, perhaps, plastic is too attached to the products that are derived from it. Unlike metal, glass, wood or ceramic, the image of plastic is often accompanied by the representation of cheap, shiny products, or disposable packaging. When we think of landfill sites, however, we think of plastic products rather than the material itself. Plastic suffers

from being too good at its job, from being used without any sense of what will happen to the material when the product is longer useful. The book also contains examples that challenge this image of plastic as the material of mass-production. In this arena designers are continuing to look at non-traditional approaches to the production of plastic as a high-volume material. In this case, the definition of plastic as a material shifts from mass-produced, identical units to the individual and personal, and with the rise in the use of rapid prototyping it is reasonable to assume that the entirely personalized product will soon be upon us. Already this can be observed to a degree in the introduction of new processing technologies, such as overmold decoration that is used to add decorative surfaces to products, personalizing them for local, cultural, and social markets. Here the expense of retooling is eliminated and plastic is given both new life and new sensorial possibilities by being allied with emotive materials such as metals, woods, and fabrics.

But plastic is also becoming more of an emotive material in its own right, one that has value as a communication tool and is able to be controlled, branded, and design-protected by the global OEMs (original equipment manufacturers), so that the material is seen as part of the product branding. Of course, the ability to mold or manufacture previously impossible shapes has meant that form-making as an expression of brand is a well-trodden area. What is perhaps more interesting, however, is the possibility for companies to explore their brand through not only the surface qualities of materials, but also the use of intelligent surfaces, or more emotive tools such as aromatic additives—a technology that exists, but which is largely unexplored territory. This area of emotive communication combined with the emerging use of nanotechnology, perhaps, may provide a platform for plastics to take on completely new meanings, functions, and roles, which essentially

means that plastics will flow and weld themselves completely into other material families. These new hybrids may provide a path to an ultimate material where all technologies melt into a single form of plastic, or lead to a time when the opposite is true, when we have so many variations that the current definitions of woods, metals, glass, and plastics vanish from our vocabulary and lose their meaning. But the purpose of this book is to provoke you into questioning and thinking about a selection of what I think are some of the most interesting, original and sometimes just plain fun plastics and plastic products in the world today.

Chris Lefteri

## How to use this book

The first, and largest, section features a range of projects, products, and processes. These look at plastics in many forms, exploring both familiar, everyday products and others that have never been published before. If you want further reading, then each feature also contains details of where to find it. Cross-references are included along the edge of each page to take you to related content. Each page or spread also breaks the material or process down into its basic properties, and a range of applications.

The second section, at the back of the book, provides a reference guide to the main plastic materials in general use, with specific information about different types of plastic and their production methods. Within this, there is a section of links to key plastics producers, organizations, and material suppliers.

# 013 Surface

# 014

Color is not often the main priority in a designer's specification. It tends to fall some way behind form and material on the sketch sheet, and often appears as the dressing once the other details are in order. However, the importance of color in design should never be understated.

Color is one of the first things we notice, consciously or unconsciously, when we look at an object. It is also one of the main driving forces behind trends, and can provide the revamping of a product's identity without the need to completely retool the product itself.

Through the addition of a masterbatch, ⬎ designers have a limitless range of possibilities for color and decoration. Masterbatches are additives to any number of molded plastic products that serve to enhance performance and/or add color and detail.

Snap was created as an alternative to the plastic color samples that are traditionally sent out to designers. The object, consisting of sixty identical components that show the eighteen colors, was created by Tom Dixon ⬎ for Gabriel-Chemie, one of Europe's leading masterbatch producers, to highlight the potential for color in the molding of plastics.

more: Masterbatch 016, 024 Tom Dixon 102–103

# Exploring color's full potential

| | |
|---|---|
| Dimensions | **360mm diameter** |
| Key features | **Decoration is embedded into the surface, which eliminates the possibility of colors being worn or scratched off** |
| | **Not limited to color; can be extended to other effects or additional properties** |
| More | **www.tomdixon.net; www.gabriel-chemie.com** |
| Typical applications | **Masterbatches are added to any number of molded plastic products to enhance performance and add color. Various masterbatches include anti-microbial additives to enhance strength and durability, wear resistance, environmental resistance, plasticizers to soften plastics, and a range of decorative effects.** |

Snap Pentakis Dodecahedron
Designer: Tom Dixon
Manufacturer: Gabriel-Chemie
Date: 2005

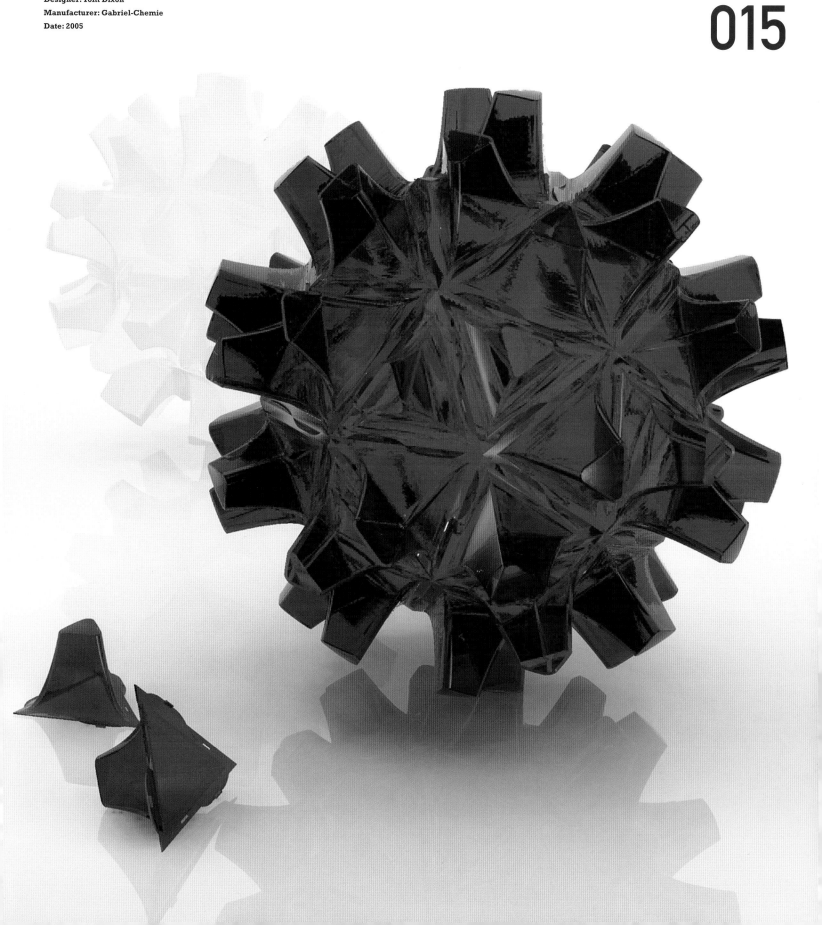

Swatches from the Enigma range of
"Splash" and "Swirl" effects.
Manufacturer: Clariant

# Splashtastic

| | |
|---|---|
| Dimensions | **Swatch size 400mm x 450mm** |
| Key features | **Unique visual effect** |
| | **Decoration is embedded into the surface, which eliminates the possibility of colors being worn or scratched off** |
| More | **www.clariant.masterbatches.com** |
| Typical applications | **The effect can be incorporated into a range of plastic materials, including HDPE, PET, polystyrene, polypropylene, PVC, and SAN. As we exhale the last breaths of minimalism, these decorative splodge effects are possibly not the first types of decoration that spring to mind, but they do provide a unique quality for a plastic molded product. On the level of fashion accessories, they can be seen as a competitor to the marbled, cloudy effects of cellulose acetate. Other potential applications include cosmetics packaging.** |

The potential of masterbatches ↘ —concentrated additives for modifying and coloring plastics— is enormous. They carry out the task of giving plastic resins enhanced features, whether those features are performance-related or, as in this case, purely esthetic.

Clariant is one of the world's leading producers of masterbatches. Along with scented, chromed, transparent, and other effects, one of Clariant's most unusual products is a decorative effect called Splash.

This special-effect concentrate uses different colored particles that are blended together in a clear or colored base-resin to form a series of smudges in the molded component. This means that specific effects can be created at the same time as the molding process, including Tortoise shell, Mosaic, Smoky Granite, and "Graffiti," which is described by Clariant as being like a crayon explosion.

Although masterbatches can be added to a whole range of plastic-processing methods, this particular effect is restricted to any injection ↘ - or blow-molded ↘ component or conversion into sheet form. These effects may not be radical in themselves, but they are new to mass production, capturing a sense of fun and celebration of color.

| Key features | Exceptional flexibility when sandwiched |
| --- | --- |
| | Excellent energy absorption |
| | Cost-effective |
| | Low cost, high production rates |
| | Recyclable |
| More | www.cellbond.com |
| Typical applications | This structural panel has uses in aerospace, architectural, marine, and automotive industries. It can be used for ceiling and roof panels in the rail and automotive industry, in the manufacture of bonnets and bumpers in cars, as decorative panels in the retail and home environments, for raised floors, interior and exterior cladding, and for room dividers. It can also be used for impact protection in transport, including the front wings of vehicles, and in exhibition stands and decorative panels. |

# Material becomes surface

There is always great innovation based on making the most from as little as possible. Many lightweight but strong panel products are built on the idea of trapping air inside a rigid geometry or the sandwiching of different materials.

PressLoad, made by British company Cellbond Composites, however, uses a clever surface design to create a valuable combination of strength, energy absorption, and lightness.

Based on the same principle as an egg box, this is a semi-formed material, born out of technical innovation and designed for a robust engineering use. It also happens to be a fascinating material visually. Originally developed as a lightweight energy absorber to compete with honeycomb and other panel products, PressLoad is more of an innovation as a surface than as a material.

There is a range of different geometries and materials according to application. Beyond thermoset ⬎ and thermoformed plastics, which include polypropylene ⬎ and polycarbonate ⬎ , the principle of this surface can also be used in aluminum alloys ⬎ . Although the standard form is a sheet, PressLoad can also be formed into curves, where it performs well as an impact absorber.

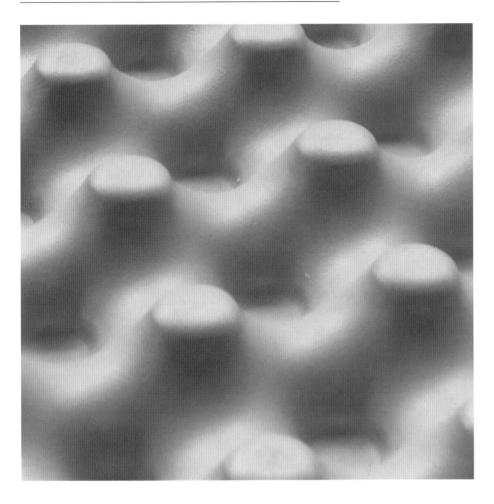

more: Aluminum 042, 043, 051, 074, 079, 080, 101, 108, 121 Polycarbonate 022, 036, 038, 050, 078 Polypropylene 018, 036, 043, 045, 073, 088, 093, 119, 125 Thermoset plastics 046, 066, 126

# 018

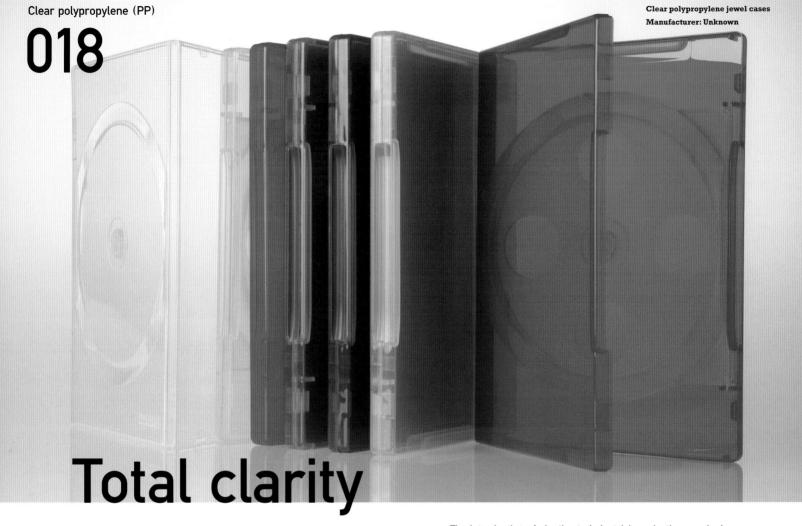

# Total clarity

| | |
|---|---|
| Dimensions | **142mm x 124mm** |
| Key features | **High clarity** |
| | **Cost-effective** |
| | **Ability to incorporate live hinges** |
| | **Widely available** |
| | **Low density** |
| | **Good chemical resistance** |
| | **Good strength and rigidity** |
| | **Recyclable** |
| More | **www.clearpp.com; www.milliken.com** |
| Typical applications | **There are numerous industries where clear polypropylene has applications. Some popular applications are in food and non-food packaging, centrifugal tubes, disposable syringes for the medical industry, and blow-molded bottles.** |

The introduction of plastics to industrial production sparked a revolution in the nature of the products that could be designed and produced. Of possibly equal significance was the point when the new super-morphing substance could be made transparent. This opened up the world of plastic to such an extent that it is now virtually synonymous with transparency.

When polypropylene (PP) ⬊ was introduced fairly recently, it ushered in a new area of possibilities for plastic products, including live hinges, cost-effectiveness, and toughness. What it lacked was the ability to be completely transparent, having a slight milky haze. When polypropylene is seen alone, this milkiness is not very evident, but when viewed next to a piece of PET (polyethylene terephthalate) ⬊, it is obvious which one is transparent.

The US-based company Milliken has a rich history of technical innovation, and since the early 1980s it has been developing clarifying agents to overcome this problem with PP. Its latest generation of clear polypropylene should help it compete more with the likes of crystal-clear PET.

# Sublime color

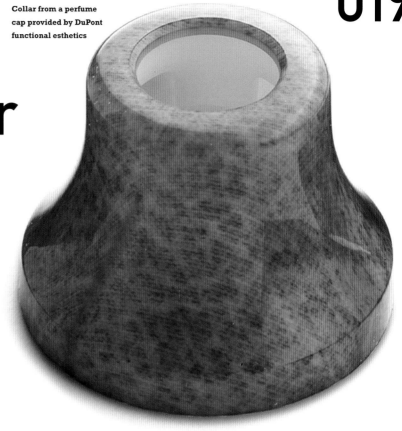

Collar from a perfume
cap provided by DuPont
functional esthetics

There are a number of methods of applying decoration and color to plastics once they have been molded. Although used for some time in the textile industry and other two-dimensional print applications, sublimation coating or painting is a new technology for surface decorating in three-dimensional plastic moldings.

Applied as a secondary process after molding, the process works by heating up the printed image or effect and vaporizing it so that it is absorbed onto the substrate. It can be used on a range of materials, with the only restriction being that the substrate is able to withstand the temperature of the process.

The sublimation coating is more than just a skin: the process embeds the pattern between 20 and 30 microns into the surface of the plastic, allowing for components to take on a variety of colors, images, and decorative effects. Because the dyes penetrate the surface of the plastic, the decoration is much more resistant to wear than other techniques, such as in-mold decoration ↘ .

The process can be used to decorate and personalize standard products without the need to retool. In particular, this can be useful for seasonal and fashion-led products, such as skis, where colors or images with exceptional resistance to wear can be applied to existing tooled designs.

| | |
|---|---|
| Dimensions | **40mm diameter** |
| Key features | **Excellent scratch and wear resistance** |
| | **High resolution** |
| | **Can be applied to a range of materials including non-plastics** |
| | **Can be used to decorate large-scale moldings** |
| | **Easy to customize parts and provide customer differentiation without retooling** |
| | **Can be applied to small- or large-scale production** |
| More | **www.kolorfusion.com** |
| | **www.functionalaesthetics.plastics.dupont.com** |
| Typical applications | **Sporting goods (e.g. skis, where a range of season-led colors or images can be applied to existing tooled designs); consumer appliances; and electronics, where a permanent wear-resistant image is required onto a molded piece** |
| | **Can be applied to a range of different materials, even on a very large scale—including, in one case, an 18-foot aluminum fishing boat.** |

more: In-mold decoration 022 ↑

# 020

# Form-dictated patterns

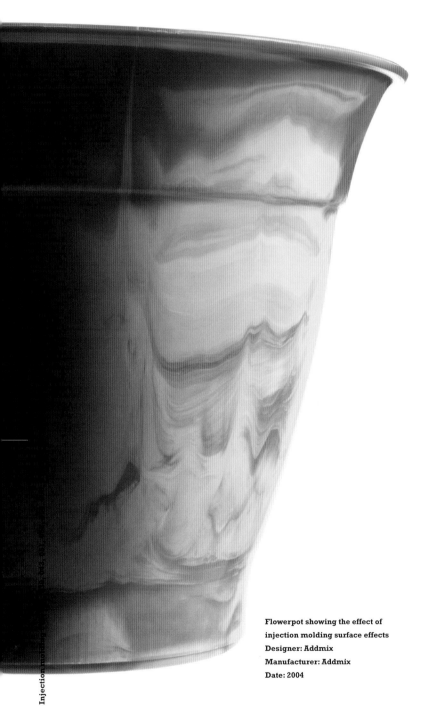

The greatness of plastic is built on the fact that each component that comes out of the machine looks exactly the same—with a high degree of technical skill ensuring this uniformity. What is particularly interesting with the intervention in the injection-molding ↘ process shown in this particular example is not just the fact that it brings a new possibility to the surface decoration of plastics, but that this marbling effect is a direct result of the form of the molded product.

London-based company Add Mix has developed a "dosing" process. Using virtually any type of granular material, the process of adding different colors during injection molding offers a way of producing plastic components where the surface decoration can be controlled to give different swirling, hippy-type effects.

The nature of these effects is the result of the flow of plastics into the cavity of the tool. Therefore, a simple shape such as a flowerpot will have a very different pattern to a more complex part with more junctions and joints. Nevertheless, because the flow of material is the same each time, the patterns can be reproduced and recreated as multiples, no matter how complicated they are.

| | |
|---|---|
| Dimensions | **220mm x 200mm diameter** |
| Key features | **Distinctive visual quality** |
| | **Existing mold** |
| | **Existing machines** |
| | **Add-on to different molding machines** |
| | **No size limitations** |
| | **Can use existing tooling to create something unique** |
| | **Can be used for performs for blow moldings** |
| More | **www.addmix.com** |
| Typical applications | **The rather craft-led esthetic of this effect means that it probably won't feature on the front cover of more high-tech style magazines, but it has potential in areas such as cosmetics, jewelry, fashion accessories, and garden furniture, where it offers a pattern similar to ceramic glazing.** |

**Flowerpot showing the effect of injection molding surface effects**
**Designer: Addmix**
**Manufacturer: Addmix**
**Date: 2004**

more: Injection molding

# Metal skins

Think of the door handles on the inside of a car, with sleek, semi-organic contours, or the caps on perfume bottles. These accessories may appear to be metal, but in many cases are merely plastic moldings with a thick, hard, protective metallic skin. This is a technology that is partly concerned with perception of products, but also the practical side of product manufacturing and assembly. Delrin® ⬎ acetal resins ⬎ and other engineering polymers ⬎ have traditionally been difficult to metalize, and although it is possible to injection-mold metals, it incurs higher costs than plastic injection molding ⬎ .

Metalizing plastics is not particularly new technology, having been used on materials such as ABS ⬎ for some time. However, what is new is their use on engineering polymers. This allows products to get one step closer not only to replicating the surface of metal, but also to some of the mechanical properties of metals.

Apart from esthetics, one of the more commercial uses is that this type of plating allows for a single engineering polymer to replace applications that might have required two components. A perfume cap, for example, would traditionally be made from two moldings —a metal-plated ABS outer cover over a chemically resistant acetyl resin. This new process allows the product to be made from a single engineering component that can be plated.

The technology means that just by looking at a product it would be impossible to know that the substrate was plastic. It is also another example of plastics encroaching on the territory of other materials, using surface as a way to combine the processing of one material with the functional and decorative surface of another.

| Key features | Allows for engineering polymers to be plated |
|---|---|
| | Decorative |
| | Corrosion-resistant |
| | Wear-resistant |
| | Hard |
| | Can be cost-effective due to the reduction in the number of components |
| More | www.functionalaesthetics.plastics.dupont.com |
| Typical applications | Door handles in cars; plating in the medical industry; perfume packaging that requires a high level of decoration combined with chemical resistance. |

Metal coated snips
Manufacturer: FPSA

more: ABS 036, 041, 047, 070, 078, 101, 115 Acetal 078, 114 Delrin 114 Engineering polymers 023, 071, 073, 076, 080
Injection molding 016, 020, 030, 043, 051, 052, 054, 058, 073, 090, 093, 097, 100, 114

# 022

**Polar S810i heart rate monitor**
**Designer: Unknown**
**Manufacturer: Polar**
**Date: 2000**

# Adventures in film

There are two noteworthy aspects to in-mold decoration ↘ using plastic films. The first is the process, in which the films are used as functional and decorative elements for enhancing molded plastic products. This allows for these printed films to be applied to molded parts during the forming process—a cost-effective method for applying a range of skins to components without secondary processing. The second aspect is to do with the films themselves.

Autotype is a leading company in the production of in-mold decorating films. Two of its most interesting films rely on some fantastic technology. The first is Autoflex MARAG™ (Motheye AntiReflection and AntiGlare). Using nanotechnology ↘ , this film replicates the eye structure of a moth, which collects as much light as possible but eliminates any reflection that might attract predators. This phenomenon has been converted into a single-layer film that has the advantage of increasing perceived brightness on a range of portable LCD displays without compromising either the viewing angle or clarity of the screen.

Another interesting product is Autoflex HiForm M. a polycarbonate film ↘ that has the ability to self-heal, repairing itself of minor scratches. The surface of the film is continually moving, which results in the scratches disappearing within 24 hours.

| Key features | Allows for virtually any pattern to be added as a skin |
| --- | --- |
| | Easy to customize products without retooling |
| | High and low production runs |
| | A range of films are available that are scratch-, chemical- and abrasion-resistant |
| | Cost-effective as it is part of the production cycle |
| More | www.autotype.com |
| Typical applications | In-mold and over-mold technology is used in a variety of forms, from the films listed above, to leather and aluminum inserts, to bonding technology. This type of in-mold decoration is used in a host of applications, including cellphone lenses, which exploit the scratch-resistant film, cases and keypads, electronic and flat-panel displays, membrane touch-switches, and interior and exterior automotive accessories. |

| Key features | Chemically dissimilar materials can be joined |
| --- | --- |
| | Permanent bond |
| | Clean technology |
| | Cost-saving |
| | Less complex than traditional mechanical joints, such as glue, screws, or welding |
| | Allows for dissimilar materials to be separated and recycled |
| More | www.dupont.com |
| Typical applications | This technology is still in its early stages, but the potential for joining dissimilar materials opens new doors to material combinations that have previously been difficult or expensive. Costs can be reduced when a part does not have to use a single expensive material when a second cheaper alternative can be used. The process also allows for hard and soft materials to be combined economically. |

# All join together

The world of fixings deserves a book all to itself, as there are thousands of combinations of materials, adhesives, mechanical fasteners, and welding. Advice on joining similar materials can be quite straightforward to obtain. However, information on joining dissimilar materials can be much harder to find (and understand). For example, engineering polymers ⬎ have always been difficult to join because of their excellent chemical resistance.

The term "micromechanical anchoring" describes a method of joining any two differing materials, including engineering polymers. The process has been developed by DuPont's ⬎ research and development center.

The project began as an investigation into how to join polyethylene (PE) ⬎ and polyoxymethylene (POM) in fuel containers—a process that had previously been achieved by welding. Researchers came up with a new process to join not only these two materials, but any two materials. It involves overmolding a porous interface sheet of plastic onto a plastic component. This component is then placed into a molding tool, where a second component in a different material can be overmolded. The porosity of the sheet allows the melted material to flow into the pores to give a gripping effect similar to Velcro® ⬎ .

This process relies on a mechanical effect rather than a chemical interface, and has a continuous in-use temperature limitation of 60°C (above this, the film is open to attack). This can be an advantage as components can be separated for recycling. The main restriction of the technology, which will probably affect low production runs of products, is that at least two of the components must be overmolded with the film.

more: DuPont 029, 030, 068, 071, 073, 076, 114 Engineering polymers 021, 071, 073, 076, 080 Polyethylene 029, 046, 052, 093, 097, 110, 119 Velcro 122–123

# 024

# Scents and sensibilities

We have mastered the art of form-making and can exploit a huge palette of tactile and decorative surfaces. The sound of a knock on a piece of timber or the springy feel of a piece of rubber are sensuous experiences that we recognize, but as we move increasingly away from form- and object-based creativity to designing "experiences," it may be that the smell of our material becomes increasingly important.

Plastic is a hard material to give life to. It is not like wood or stone, which release an odor when carved, or like metal, which requires polishing to maintain its surface sheen. Usually, the only thing you need to do with a plastic product is take it out of its box and perhaps plug it in. This in itself is a sensuous experience—the smell of something new rather than of something trying to disguise itself as something else.

Although the ability to add additional smell to plastics has been around for some time, it has yet to make a significant impact on products. This is partly due to the fact that until recently the scents have only been superficial and have eventually rubbed off, but it may also be due to the fact that most of the smells designed by the various manufacturers have shared a similar, sweetly artificial fragrance. This is a pity as smell is the most evocative of senses, but if the memories it evokes are of air fresheners, then why bother?

The automotive industry is one area where the smell of materials is important, as it has to be considered in the design of the confined, personal space of a vehicle's interior.

As technology has progressed to allow us to add long-lasting smells to plastic products through additives in a masterbatch ↘, then perhaps the day will come when brand owners start to embody their brand in a truly evocative or memorable scent. Of course, the challenge lies in creating scents that do not put people off mass-market products, so it may be that scent becomes the main attraction of a given plastic product rather than a perhaps controversial addition to something familiar.

| Key features | Scents can be incorporated into moldings as an additive |
| --- | --- |
| | Scents can last for up to twenty years |
| | Cost-efficient |
| More | www.eastmaninnovationlab.com |
| | www.masterbatches.com |
| | www.thebrewery-london.com |
| Typical applications | Current applications are limited to novelty items and stationery. |

**Scented Pebbles**
**Designer: The Brewery**
**Client: Eastman Chemicals**
**Date: 2004**

more: Masterbatch 014–015, 016

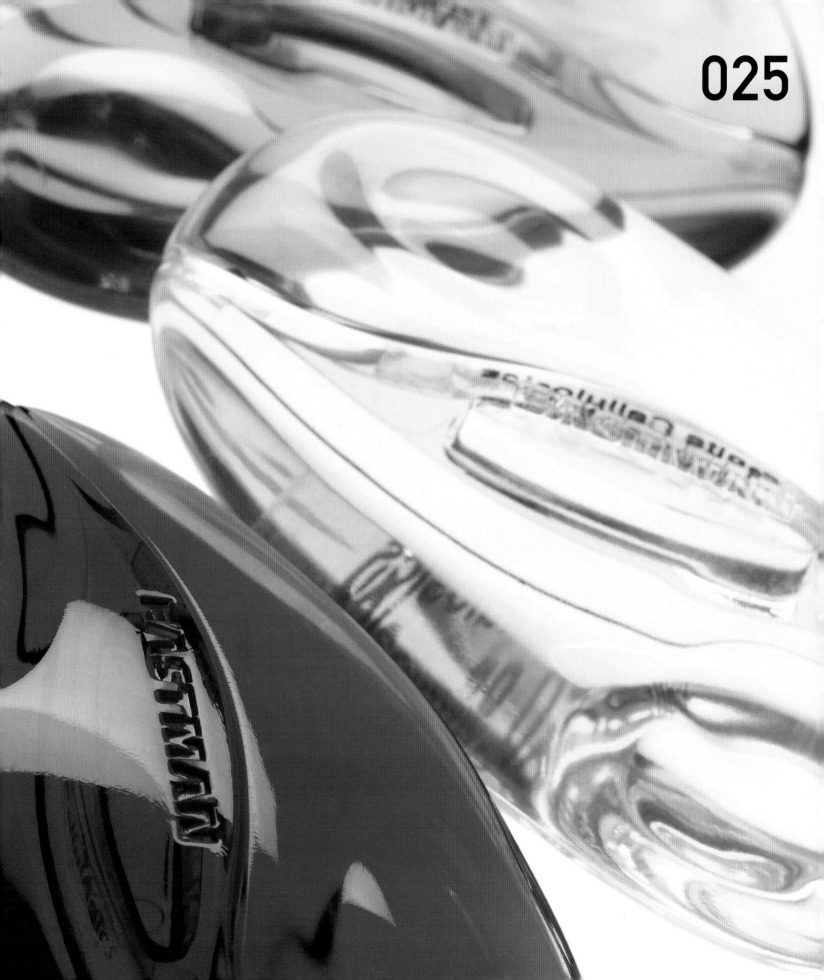

025

# Invisible made visible

The interesting aspect of any type of thermochromic ⬎ technology is that it makes visible that which is inherently invisible. It can take the warmth from your hand, for example, and convert it into a series of colors, thereby providing a new way of seeing our environment.

This type of color-changing technology can take various forms. Liquid-crystal thermochromics, for example, are based on the coding of different temperatures into a series of colors. This is the technology behind forehead thermometers, where the change in temperature is reflected by a different color.

UK-based company ChromaZone is unique in the fact that it can supply anything from the initial powder and ink to a semi-finished thermochromic sheet or a finished thermometer. One particularly interesting product that the company produces is a heat-sensing ink in the form of a crayon.

ChromaZone is now looking at new applications for the products. The company has worked with a number of designers, including a fashion designer who has incorporated the technology into textiles.

| Key features | Can be used in a variety of forms |
| --- | --- |
| | Reversible or non-reversible. |
| | Can be printed or molded |
| | High visual appeal |
| | Good safety potential |
| | Fun |
| More | www.chromazone.co.uk |
| Typical applications | Thermochromics can be used in sheet form, printable form, and as a masterbatch additive to a molded product. Thermochromics are found in everything from children's products for testing the temperature of food and drink to industrial safety signage. They are also used in promotional products, sunglasses, packaging for batteries, novelty products, mood rings, and food packaging. |

more: Thermochromics 054, 064

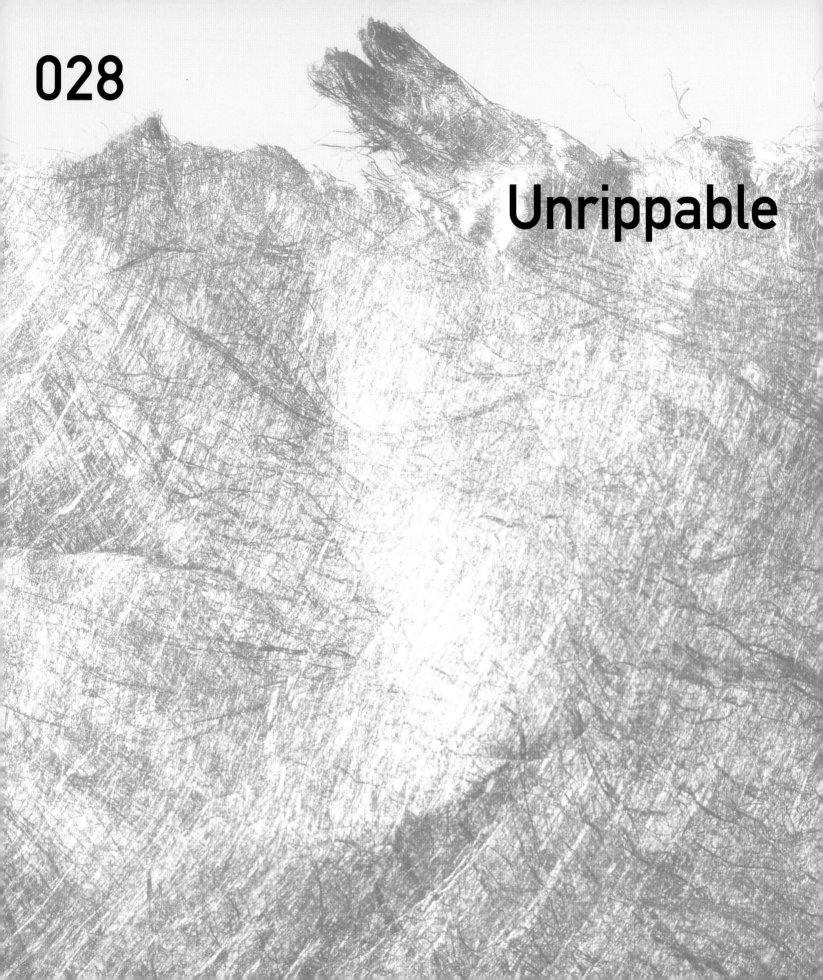

028

Unrippable

Welcome to the most exciting envelope material ever: a plastic that can be printed, glued, sewn, and, when you have finished with it, can be recycled and converted to car parts, underground cables, and blown film!

Tyvek® is an HDPE (high-density polyethylene fiber) ↘ —a plastic that thinks it's a paper. Tyvek® is one of the most well-known brands. If you don't know this brand by name, you will know it by the waxy, paper-thin, plastic sheet that is used to make, among other things, virtually unrippable courier envelopes. The texture of the material is the result of the strands of polyethylene ↘ in its cross-linked structure.

Aware of the product's potential in other markets, DuPont ↘ has also introduced a range of metallic colors.

TYVEK® is produced in three different types: 10, 14, and 16. The fibers in Type 10 style are bonded to form a tough, dense, opaque sheet. The dense packing of the fine, interconnected fibers produces a smooth surface, high opacity, and whiteness. The large number of bonds per unit area results in a stable and abrasion-resistant surface with a stiffness similar to paper. Fiber bonding of Types 14 and 16 is restricted to discrete points in the non-woven sheet. This produces a high degree of fiber mobility, and gives the non-woven sheet a fabric-like drape.

Tyvek® behaves like any paper product: you can write on it using pencil or pen, pencil marks can be rubbed out, it will not tear at folds, and it can be folded 20,000 times without wearing out. It even floats. When a hole is punched in it, this doesn't weaken the material. Tyvek® is printable by most common techniques (except hot laser and photocopying), and can be printed on most computer printers. With a material like this, who needs trees!

| Key features | Super-strong |
| --- | --- |
| | Lightweight |
| | Good liquid hold-out characteristics |
| | Strong and tear-resistant |
| | Weather-resistant |
| | Resists continuous folding and flexing |
| | Keeps properties across a wide range of temperatures |
| | Unaffected by most chemicals |
| | Non-toxic |
| | Chemically inert |
| | Conforms to International Maritime Dangerous Goods labeling code (also BS 5609). |
| | Approved for contact with foodstuffs and cosmetics |
| | Conforms to draft EC directives on packaging waste and German legislation on compatible labeling. |
| More | http://www.duponttyvek.com/ |
| Typical applications | Security envelopes; protective apparel; specialty packaging; roofing membranes; tags and labels; banners; maps; money; reinforcement; and kites. |

Sample of DuPont Tyvek®

more: DuPont 023, 030, 068, 071, 073, 076, 114 HDPE 110 Polyethylene 023, 046, 052, 093, 097, 110, 119

# Slippery customers

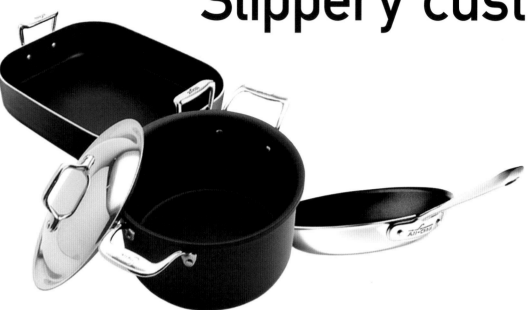

more: DuPont 023, 029, 068, 071, 073, 076, 114 Extrusion 058, 073, 088, 090, 093, 102, 108, 114, 120 Injection molding 016, 020, 021, 043, 051, 052, 054, 058, 073, 090, 093, 097, 100, 114
Nylon 066, 068, 071, 074, 114, 122, 124 PTFE 114 Teflon 122

PTFEs ➘ are generally known by the common name of Teflon® ➘ , a word that has become synonymous with non-stick. Teflon® is a household product and a household name. Accounting for ninety percent of all fluoroplastics, Teflon® is a material that was discovered by accident in the same year as nylon ➘ —1938—by Dr Roy Plunkett. He was a DuPont ➘ chemist who is placed among Thomas Edison, Louis Pasteur, and the Wright Brothers in the United States' National Inventors' Hall of Fame. Along with so many other DuPont materials and success stories, Teflon® was in Neil Armstrong's and Buzz Aldrin's space suits when they landed on the moon in 1969.

Teflon® is smooth and slippery to the touch. It is heat-resistant up to 260 degrees and is available as a sheet, film, thread, tubing, and rod. Grades can be produced to allow it to be created by a number of different processes, including injection ➘ - and compression-molding and extrusion ➘ . More famously, it can also be used as a protective covering.

| Key features | Astonishing chemical resistance |
| --- | --- |
| | Excellent mechanical strength |
| | Self-lubricating |
| | Low friction coefficient |
| | Excellent electrical insulation properties |
| | Maintains properties through a range of temperatures |
| | Good UV and weather resistance |
| | Transparent |
| More | www.dupont.com/teflon |
| Typical applications | Bearings; gear wheels; surgical prosthetics; coating for cookware; washers; electrical sleeving; cake tins; stain repellent for fabrics and textile products; tubing and piping in the semiconductor industry; and anti-corrosion surface coatings. |

# 033 Commodity Polymers

# 034

Bright space Geodesic structure
Designer: Nick Gant
Manufacturer: Bright
Date: 2004

# Paper-thin buildings

more: Copolyester 086 Eastman Chemicals 086, 102 PETG 102, 120

| Key features | High-impact resistance |
| --- | --- |
| | Clarity |
| | Tough |
| | Chemically resistant |
| | Odor-free |
| | Cost-effective |
| | No whitening on fold lines |
| More | www.bobodesign.co.uk/bright |
| | www.eastman.com |
| | www.barloplastics.com |
| Typical applications | Signs and displays, which exploit the material's ability to be easily cut, bent—hot or cold—and printed. A more exotic use for the Spectar® brand was its use in creating the ice palace in the 2002 James Bond movie Die Another Day. Spectar® sheet can be routed, welded, drilled, die-punched, or joined by screws, rivets, or bolts. It can also be cut on conventional table, band, or radial-arm saws. It accepts screen-printing, painting, and hot-stamping easily. Surface scratches or scuff marks can be removed using a heat gun. Even strong cleaning solutions will not affect the material's transparency. |

Flat-pack usually implies packaging and furniture made from rigid cardboard, wood, or similarly inflexible materials. The structures designed by Nick Gant for British company Bright challenge this notion: they are produced from an ultra-thin, lightweight PETG (polyethylene terephtalate glyco) ➘ plastic material.

Using a folded plastic sheet that is extremely thin (0.75mm), these incredible geodesic structures are rigid and self-supporting. The beauty of this design lies in the use of such a thin sheet on such a large scale without the need for an internal framework to support the sheets. Using the principle of origami, which uses the inherent strength of a fold to make three-dimensional structures, the design explores the application of a plastic in a new context. Another aspect that makes this project unique is that it eliminates the need to include fragile sheets of glass in order to obtain total transparency in a building.

The image shows the domes made from Spectar®, a transparent copolyester sheet ➘ from Eastman Chemicals ➘. This material has massive potential in display and advertising due to its ability to deal with graffiti, as scratches and scuff marks can be removed with a heat gun.

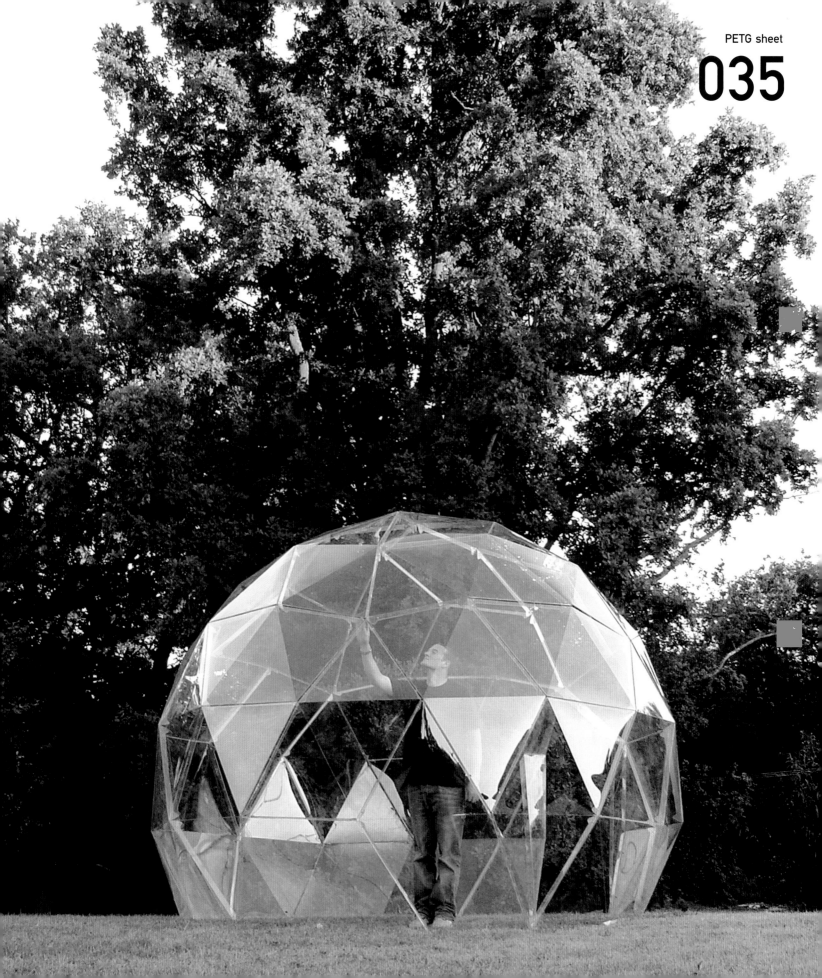

# 036

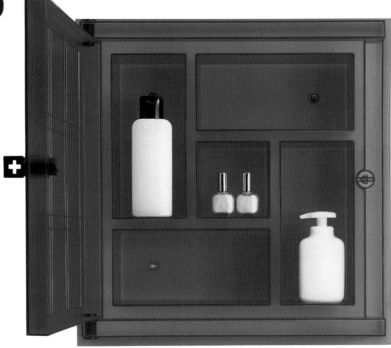

**Salute multipurpose wall cabinet**
**Designer: Harry Allen**
**Year of production: 2000**

| | |
|---|---|
| Dimensions | **550mm wide x 550mm high** |
| Key features | **Water-clear** |
| | **Tough** |
| | **Colors and decorates easily** |
| | **Easy to process** |
| | **Chemical-resistant** |
| | **Alcohol-resistant** |
| | **FDA and USP Class VI-compliant** |
| | **Anti-static and indoor UV grades available** |
| More | **www.novachemicals.com** |
| | **www.zylar.com/main.htm** |
| | **www.magisdesign.it** |
| Typical applications | **As an alternative to polycarbonates, acrylics, and PETG, Zylar® has been used in all sorts of industries including toys, computer accessories, cosmetics packaging, medical devices, water filter jugs, point-of-sale displays, tap handles, office work tools, and house wares.** |

If plastics are the material of disposability and cheapness, then why are we happy to have so much of the stuff in our homes? Plastics have been used for domestic applications since their first introduction. It is well known that some of the early plastics, including casein (a substance found in milk), were used for jewelry and other precious objects. These products were considered valuable purely because they made use of what was then an advanced material. Then, in the late 1940s, Tupperware promised a more rational and practical use of the material in our homes, and since then plastics have become common. The esthetic of the 1960s helped fuel this, along with the relatively recent introduction of polypropylene ⟍ into the stable of rapidly expanding plastic materials.

The Italian furniture and accessory manufacturer Magis ⟍ has built a family of products that celebrates plastics in the home. Along the way, it has created some iconic designs in unexplored typologies, generating "happy and colorful projects that communicate exemplary design."

In this Magis project, Zylar®, a high-performance styrenic ⟍ , has been used in a product that requires a particular toughness. Zylar® is an impact-modified SAN (styrene acrylonitrile) ⟍ , formulated as a stiff, resilient, easy-to-process, and competitively priced alternative to other terpolymers, such as ABS (acrylonitrile butadiene styrene) ⟍ . According to the producers, Nova Chemicals ⟍ , Zylar® is also more cost-effective during molding than traditionally tough polycarbonate ⟍ .

# Celebrating plastic

# Dense and light

The wonderful quality that EPP (expanded polypropylene) ⬎ has to offer is that it combines an incredibly lightweight structure with outstanding density relative to its weight.

The sample responds to many of the key features of the material, including its ability to be formed into large solid-wall thicknesses. It can also be colored or printed, and surface patterns and graphics can be molded into the surface. Chairs can also be made available with different color combinations in the same components, giving a mottled, multicolored effect.

Apart from standalone components and products, various manufacturers have also developed technology where EPP can be molded directly into the casings of other components, thereby reducing assembly times and costs.

If you look at this material without any preconceptions of its more typical applications, it frees your mind to a world of new possibilities for this underused material and its unique set of characteristics.

| Key features | Excellent energy absorption |
| --- | --- |
| | Very good cushioning |
| | High service temperature |
| | Available in a range of densities 12g/l–240g/l (grams per liter) |
| | Colorable |
| | Recyclable |
| More | www.styreneforum.org |
| | www.tuscarora.com |
| Typical applications | A combination of properties makes this prolific material useful for a massive range of applications, including surfboards, bicycle helmets, fruit and vegetable trays, insulation blocks, head-impact protection in car headrests, bumper cores, steering column fillers, and in acoustic dampening. EPP can also incorporate in-built springs for extra protection in packaging. |

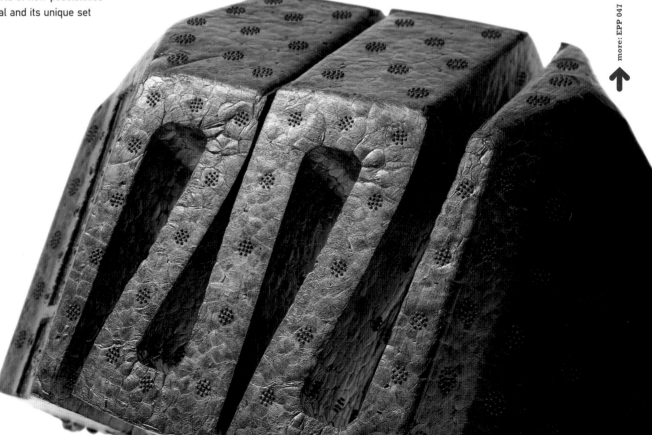

Sample of EPP foam used as a flexible cushion. Part of author's collection. Manufacturer: Unknown

more: EPP 047

# 038

It is always interesting to see material combinations. In composites, the physical and visual properties work off each other to create new technologies with enhanced properties. Interesting effects can also be created from "marriages" of materials.

These containers from the Italian manufacturer Alessi combine two materials: corrosion- and scratch-resistant stainless steel ↘, and a transparent acrylic ↘ peripheral skin. This combination links the production and material heritage of Alessi's stainless steel collections with a move to plastics.

Acrylic was used for aircraft cockpit covers in World War II, a time when the new transparency of plastic was expected to take over from glass in the automotive industry. Today, acrylic is still the choice for clarity and is often viewed as the material closest to glass in this respect.

Unless blended with other plastics such as PVC ↘ which improves its impact strength, acrylic does have some of the fragility of glass. There are other materials, such as polystyrene ↘ , PET ↘ , SAN ↘ , and polycarbonate ↘ that compete for clarity, but acrylic falls between polystyrene and polycarbonate for cost.

Apart from its availability as a resin, it is also a hugely popular sheet material sold under the Perspex, Plexiglas, or Lucite trade names.

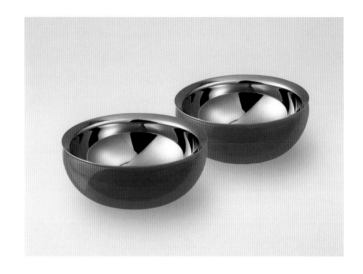

| Dimensions | Small Love bowls 120mm x 50mm |
| --- | --- |
| | Super Love bowl 300mm x 100mm |
| Key features | Sparkling clarity |
| | Good hardness and stiffness |
| | Good weatherability |
| | Good chemical resistance |
| | Available in a range of semi-finished rods, tubes, and sheets |
| More | www.alessi.com |
| | www.ineosacrylic.com |
| Typical applications | Apart from its use in paints and fabrics, acrylic is readily available as rods, tubes, or cast and extruded sheets. It is used for clear kitchen food mixers and other domestic appliances, lighting, furniture, glazing, interior screens, lenses, signage, car tail lights, furniture, and drafting equipment from the time when designers still used pencils to produce technical drawings. Acrylic is also the main ingredient for DuPont's solid surface material Corian®. |

# Glass-like clarity

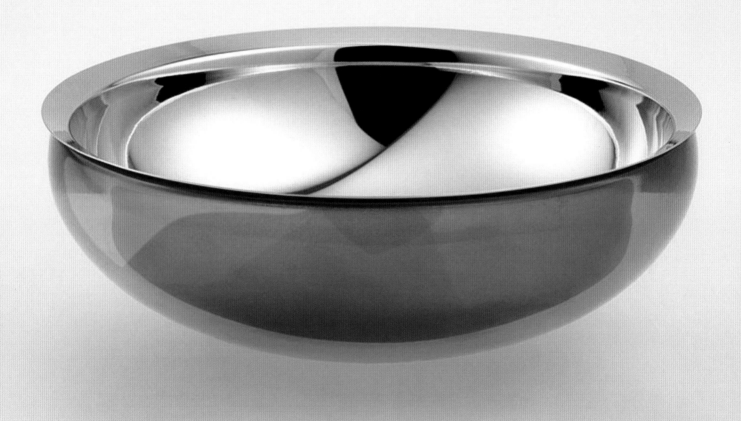

**Love bowls**
**Designer: Miriam Mirri**
**Manufacturer: Alessi**
**Date: 2004**

# 040

"212 On Ice" perfume bottle
Designer: Carolina Herrera NY
Manufacturer: Antonio Puig, S.A.
Date: 2001

# Clear alternative

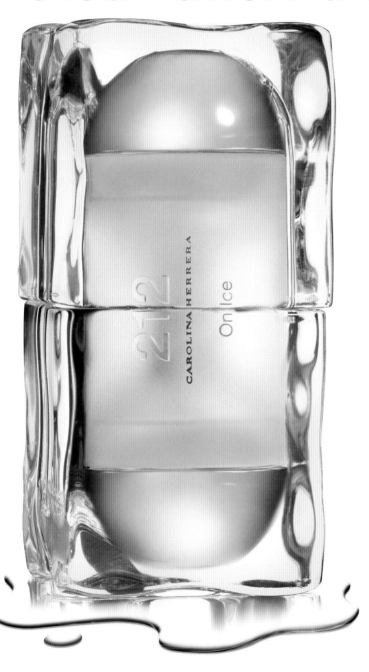

There is a seductiveness about a material that is solid and tough enough to withstand abuse but which has a water-like clarity. Clarity has been a preoccupation of design since the first clear plastics were developed. The molding of clarity offers our senses the chance to be cheated with solid, rigid enclosures containing electronics, packaging, and other objects.

Nas® is a brand of SMMA (styrene methylmethacrylate copolymer) from Nova Chemicals ↘ . It is marketed as a transparent alternative to SAN ↘ , clear polystyrene ↘ , and acrylic ↘ , or for applications that require strong, stiff, clear components. It is also promoted as a lower-cost alternative to some of these plastics due to its ease of processing and lower density, which means more parts per kilogram of resin.

We take it for granted that transparent plastics are unexceptional, but before the invention of this relatively new material the only thing that was transparent was glass. Constricted by its fragility, risk when broken, and molding limitations, glass's impact on mass-production has been limited. The introduction of clear plastics heralded a quiet revolution in packaging, furniture, safety devices, medical, transport, and a wealth of other markets. Transparency is now a design language, enabling reinvention and reinterpretation, from Daniel Weil's plastic bag radio to the original Apple iMac.

| Dimensions | 130mm height x 62mm width x 62mm depth |
| --- | --- |
| Key features | Tough |
| | Colors and decorates easily by print, hot stamp, and metalizing |
| | Sparkling clarity |
| | Lower density means more parts per kilogram of resin |
| | Low-cost processing |
| | Chemical-resistant |
| | Alcohol-resistant |
| | UL94 HB-approved |
| | FDA and USP Class VI-compliant |
| | Antistatic and indoor UV grades available |
| More | www.novachem.com |
| Typical applications | Tumblers; perfume bottle caps; handles for taps; medical devices; toys; waterfilter jugs; domestic cleaning appliances; transparent rigid coat hangers. |

more: Acrylic 038, 041, 078 Nova Chemicals 036 Polystyrene 038, 042, 041, 078, 093 SAN 036, 038, 047, 078

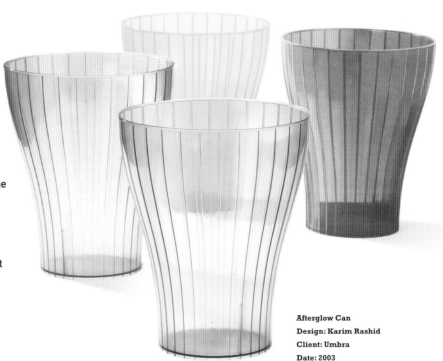

The transparency of plastics has been one of the key reasons for their use in replacing traditional materials. Although acrylic ⬎ is the plastic that most resembles glass in terms of its clarity, there are other materials that combine transparency with enhanced functions.

ABS ⬎ is a terpolymer ⬎ made up from three components, or, in technical terms, three monomers. A typical blend of ABS contains about 20 percent rubber, 25 percent acrylonitrile ⬎, and 55 percent styrene ⬎. It is a material that is primarily categorized by its toughness, but is also notable for its ease of processing, low cost, and transparency.

**Afterglow Can**
**Design: Karim Rashid**
**Client: Umbra**
**Date: 2003**

# Can-do colors

The introduction of transparency into the molding of plastics has allowed designers to create objects that would previously have required an exceptional level of craftsmanship, or which would have been impossible.

Designer Karim Rashid ⬎ has ventured into nearly every area of design, including furniture and textiles, and even pet products. Following on from the enormous success of his Garbino trashcan, also from Umbra, Rashid has produced a series of new cans. These reflect the linear, veined, optical qualities of automobile tail lights and display an honest approach to waste, allowing a colored vapor to surround the visible contents and contribute to the domestic landscape.

| Dimensions | 260mm x 305mm |
| --- | --- |
| Key features | **High-impact strength, even at low temperatures** |
| | **Low cost** |
| | **Versatile production** |
| | **Good resistance to chemicals** |
| | **Good dimensional stability** |
| | **Hard and scratch-resistant** |
| | **Flame-resistant** |
| | **Can achieve a high gloss** |
| | **Excellent mechanical strength and stiffness** |
| More | **www.karimrashid.com** |
| | **www.geplastics.com** |
| | **www.basf.com** |
| Typical applications | **In its pure form, ABS is used in many industrial and consumer applications, including white goods, telephones, housings for consumer electronics, vacuum cleaners, car parts, and food processors. There is also a range where it is blended with PVC or PC to increase toughness for use in products such as cellphone casings.** |

more: ABS 021, 036, 047, 070, 078, 101, 115 Acrylic 038, 040, 078 Acrylonitrile 070 Karim Rashid 044–045, 116–117 Styrene 036, 046, 047, 066, 070 Terpolymer 070

# Plastic to go

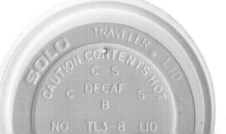

| Key features | Quite brittle in its pure form; blending it increases strength but reduces optical clarity |
| --- | --- |
| | Food-safe |
| | Easy to mold |
| | Clear and low cost |
| | Low shrinkage rate |
| | Low moisture absorption |
| More | www.dow.com/styron/index.htm |
| | www.huntsman.com |
| | www.atofina.com |
| Typical applications | Polystyrene is used widely for disposable cutlery, cups, plates, and food packaging. Expanded polystyrene is used as a packing material and thermal insulation. Other applications include CD cases, disposable pens and razors, refrigerator compartments, and model kits. |

Disposable coffee-cup lids are a product of our time; they are a cultural statement about our habits, fashions, and lifestyles. Anyone finding these objects in the distant future might wonder why there are so many different shapes and surface patterns for something so banal as stopping your coffee spilling while you walk. It seems that for every cup of coffee there is a different product, with its own strangely decorated channels, from the lid that you completely remove to the lid with tearable flaps or sliding doors.

Within these peculiarly decorated functional surfaces is an interface between the drink and our lips. This landscape of ribs, channels, and text gives us clues about the material and molding technologies. These are structural forms that owe their shape to a combination of mechanics and esthetics.

With regards to the material, polystyrene ↘ is from the commodity group of plastics—materials that are common, easy to mold, and cheap. On its own, polystyrene is quite a brittle material, but, as with many other commodity plastics, it crosses boundaries between resins, foams, and grades of impact-resistance. Like the aluminum ↘ ringpulls on beverage cans, coffee-cup lids hide a set of material and manufacturing rules that ensures they fulfil simple functions in the daily rituals that form a part of billions of lives.

# Power stools

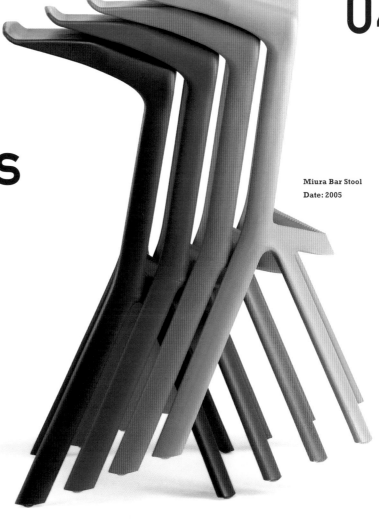

Miura Bar Stool
Date: 2005

This stool is a wonderful combination of material and product. Within its dynamic, stealth esthetic lays an example of a structural use of plastic that is rarely seen.

There are chairs and stools that combine stable shapes and thin wall thickness to create strong structures, but they all seem to follow the same principles of form combined with established material. The Air chair by designer Jasper Morrison, for example, uses air injection molding ↘ to offer us a lightweight chair, but even that follows the same rules of form, with four legs and a backrest.

What Miura offers us though this shape is almost unprecedented as a plastic molding in a single piece, with its off-balance structure and cantilevered seat looking instead like something that should be cast from aluminium ↘ . Indeed, the manufacturers of this stool claim it is two-and-a-half times stronger than aluminum.

In its pure state polypropylene ↘ can be easily tailored to control its various features. For a commodity plastic it is reasonably stiff and rigid but, as with any plastic, the addition of reinforcement takes it to new levels of strength and stiffness.

| Dimensions | 470mm x 400mm x 810mm |
|---|---|
| Key features | **Widely available** |
| | **Low density** |
| | **Good strength and rigidity** |
| | **Cost effective** |
| | **Ability to incorporate live hinges** |
| | **Good chemical resistance** |
| | **Recyclable** |
| More | **www.plank.it** |
| | **www.konstantin-grcic.com** |
| Typical applications | **Clear polypropylene has applications in food and non-food packaging; centrifugal tubes and disposable syringes for the medical industry, blow-molded bottles, food containers.** |

more: Aluminum 017, 042, 051, 074, 079, 080, 101, 108, 121 Injection molding 016, 020, 021, 030, 051, 052, 054, 058, 073, 090, 093, 097, 100, 114 Polypropylene 017, 018, 036, 045, 073, 088, 093, 119, 125

dish soap
concentrated formula
aroma: lavender

25 fl oz (739ml)

m

method™

dish soap
concentrated formula
aroma: cucumber

25 fl oz (739ml)

# Plastic as brand

| Dimensions | 250mm x 105mm x 330mm |
| --- | --- |
| Key features | Waxy |
| | Easy to mold |
| | Tough at low temperatures |
| | Low cost |
| | Flexible |
| | Good chemical resistance |
| More | www.karimrashid.com |
| | www.methodhome.com |
| Typical applications | A number of large-scale children's toys are made from HDPE. Other products include chemical drums, toys, household and kitchenware, cable insulation, carrier bags, car fuel tanks, furniture, and the iconic Tupperware. |

more: Karim Rashid 041, 116–117 Polypropylene 017, 018, 036, 043, 073, 088, 093, 119, 125 Steel 074, 108

Plastic has slowly replaced many other materials in packaging applications. From the time when rust-resistant polypropylene ⬂ was used to replace heavy, awkward, steel ⬂ paint tins, plastics have proved user-friendly alternatives to metals, glass, and other materials.

The squeezy, succulent, and curvy outline of this soap bottle not only makes for a logical ergonomic shape, but also a highly distinctive brand identity. Designer Karim Rashid ⬂ has a language of shape and color that is individual while also appealing to the mass market. There is no difference in the basic material from any ordinary washing-up-liquid bottle, but the use of translucent material, sensuous curves, and silky, waxy surface (combined with the smell of the soap) provide a multisensory experience.

This unique design strengthens the brand of the San Francisco-based manufacturer Method, which was conceived as an alternative, environmentally friendly range of cleaning products. The company was set up by Adam Lowry, an environmental scientist and chemical engineer, and Eric Ryan, who had a background in branding. The original aim of the company was to "to evolve the household cleaner from a toxic object that hid under the sink to an all-natural, biodegradable, and stylish counter-top accessory." The design for the soap dispenser moves away from a purely two-dimensional approach to branding into a statement based on material and form.

High-density polyethylene (HDPE)

# 045

m

**method**

dish soap

concentrated formula

aroma: mint

25 fl oz (739ml)

**3Pin2 Dish Soap**
**Designer: Karim Rashid**
**Manufacturer: Method**
**Date: 2002**

# 046

# Roll with it

The selection of the right material for an application can be daunting. There are hundreds of possible initial avenues, and that is before you start exploring different grades of material, all with classifications and sub-classifications. Possibly the most common way of classifying plastics is thermoset ↘ , thermoplastics ↘ groupings. However, within these groupings there are other ways of classifying materials in order to make the selection in the right application easier.

Polyolefins exist in the thermoplastics branch, alongside vinyls ↘ and styrenes ↘ . Polyolefins, however, account for the largest volume of all resins in world production, with about one-third accounted for by polyethylene ↘ . Polyethylene is a major part of this group, partly due to its availability in different densities. The most common types of PE are low, medium, and high. It is also available as ultrahigh molecular weight.

Made from a blow-molding ↘ grade of high-density polyethylene, this chair by Ron Arad for the Italian manufacturer Magis ↘ allows for a seamless form in this resilient material.

| Dimensions | 784mm high x 601mm wide x 1148mm deep |
| --- | --- |
| Key features | Rigid |
| | Low-impact strength |
| | High-tensile strength |
| | Waxy |
| | Easy to mold |
| | Tough at low temperatures |
| | Low cost |
| | Flexible |
| | Good chemical resistance |
| More | www.magisdesign.com |
| | www.ronarad.com |
| | www.cpchem.com |
| Typical applications | Toys; household and kitchenware; sporting goods; carrier bags; furniture. |

**Voido chair**
**Designer: Ron Arad**
**Client: Magis**
**Date: 2005**

**Cloud Modules**
**Designers: Ronan & Erwan Bouroullec**
**Date: 2002**

The most banal applications of materials can disguise the fact that they have far richer applications than we might assume. Fitting snugly between the walls of the cardboard box and the protected product inside it is a humble, low-density, solid material that has unexplored potential: expanded polystyrene (EPS).

Polystyrene ⊾ belongs to the styrene ⊾ family of polymers, along with ABS (acrylonitrile butadiene styrene) ⊾ , SAN (styrene acrylonitrile) ⊾ , ASA (acrylic styrene acrylonitrile) ⊾ , and HIPS (high-impact polystyrene).

The production of polystyrene foam is based on tiny polystyrene beads that are expanded to forty times their original size using a flow of steam and pentane. Steam is also used in the final phase to inject the material into the mold. In

# 98 percent air

comparison to EPP ⊾ foam, polystyrene is less of a performance material, not having the range of densities, flexibility, and strength.

Although it is 98 percent air, polystyrene is often perceived as not being a friend of the environment. However, industry is keen to point out that polystyrene foam has never used CFCs (chlorofluorocarbons) or HCFCs (hydrochlorofluorocarbons) during production. Perception of the big and bulky bits of packaging not being recycled but left to accumulate also enforces this perception. As a result, major steps have taken place in the last few years to provide recycling facilities. Once collected, the waste can be compacted and used to remold in its compacted form or ground down to form new products.

| | |
|---|---|
| Dimensions | 1050mm x 1875mm x 400mm |
| Key features | Cheap |
| | Lightweight |
| | Durable |
| | Good insulation properties |
| | Shock absorbency |
| | Low hardness |
| | Insulating |
| | Recycled |
| | Easily branded |
| | Cushioning |
| More | www.eps.co.uk |
| | www.tuscarora.com |
| | www.kay-metzeler.com |
| | www.cappellini.it |
| | www.bouroullec.com |
| Typical applications | Typically found in disposable drinking cups for hot and cold drinks, expanded polystyrene has also been used on a much larger scale; for example, in housing in the Netherlands as a buoyant platform. A house in the UK has also been made entirely from expanded polystyrene. In horticultural applications, it is used to control temperature around root growth. In other forms, polystyrene foam is extruded and then thermoformed into trays and egg boxes. |

more: ABS 021, 036, 041, 070, 078, 101, 115 ASA 070 EPP 037 Polystyrene 038, 040, 042, 078, 093 SAN 036, 038, 040, 078 Styrene 036, 041, 046, 066, 070

# 049 Smart Plastics

# 050

# Plastic with a shelf life

Here's the idea. You are a busy person, with too many little jobs that fill your day: telephone calls, appointments, washing, ironing, relaxing, and eating. You want to rent a movie, but first you have to drive to the store to pick up the movie—and later, to return the disk. Time taking your DVD back is wasted time. Can you really be bothered?

But then you find out about Flexplay, a type of DVD that expires 48 hours after opening the package. No need to take the movie back; just let the information die. Unopened, the disk stays "fresh" in the package for about a year. Once exposed to oxygen, you have 48 hours to play the disk as many times as you want in any standard DVD player. After 48 hours, your time is up and the disk turns from bright red to black and is no longer playable. Just recycle the now-useless polycarbonate ⅴ disk.

You can imagine how this scenario was put together to pitch the idea to distributors. However, what is most interesting about this technology is not the fact that it might change the way we rent movies, because that is open to other electronic technologies, but that it raises the question: what if more products and plastics were like organic matter, and had shorter natural lifespans?

| Dimensions | 120mm diameter |
|---|---|
| Key features | Based on an existing polycarbonate substrate, the new key feature is that of data with a shelf life |
| More | www.flexplay.com |
| | www.geplastics.com |
| Typical applications | The technology raises ethical questions about whether consumers will actually recycle the disks or just trash them. This type of technology has the potential to change the way we respond to products and affect the life cycles of plastic production and distribution. |

Flexplay ez-D™ 48-hour no-return DVD
Manufacturer: Flexplay Technologies, Inc
Date: 2003

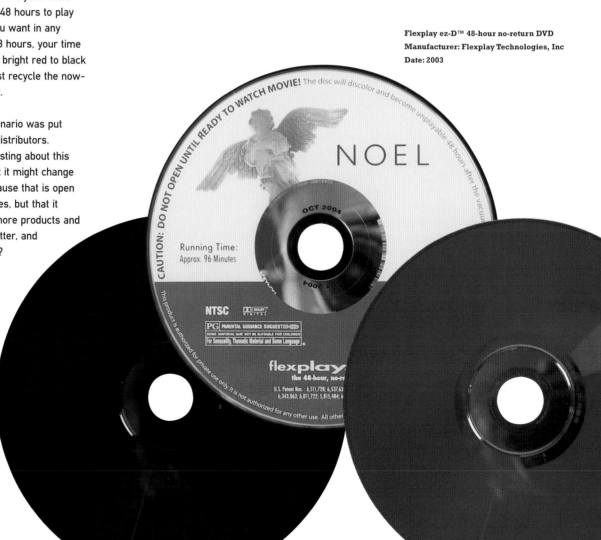

CAUTION: DO NOT OPEN UNTIL READY TO WATCH MOVIE! The disc will discolor and become unplayable 48 hours after the vacuu...

NOEL

OCT 2004

Running Time:
Approx. 96 Minutes

NTSC   DOLBY DIGITAL

PG PARENTAL GUIDANCE SUGGESTED
SOME MATERIAL MAY NOT BE SUITABLE FOR CHILDREN
For Sensuality, Thematic Material and Some Language

flexplay
the 48-hour, no-re...

U.S. Patent Nos.: 6,511,720; 6,537,63...
6,343,063; 6,011,722; 5,815,484; 6...

This product is authorized for private use only. It is not authorized for any other use. All other...

Industrial component made
by nanomolding aluminum
to plastic

The impact of nanotechnology ↘ has yet to be felt
in consumer applications. For most consumers,
it is still regarded as a technology that floats
above common understanding in a fog of
promise and complexity. It is, however, an area
of materials research that guarantees to provide
a massive change in how materials can be used
and what they will, ultimately, be able to do. This
case study from Japan uses a form of
nanotechnology in the bonding of materials.

Injection assembly technology was developed to
allow for different plastic materials to be bonded
with aluminum ↘ in the injection-molding ↘ tool
during the molding process. The process is
based in the use of a nanotechnology to indent
the surface of the aluminum so that it acts like
an anchor for the plastic resin. The nano surface
is applied by dipping the aluminum in a liquid
solution, where the surface is transformed from
a plate-like structure into an almost porous
arrangement. The metal blank is then inserted
into the mold, onto which the resin is injected.
The resulting bond is extremely strong, forming
a joint that is as strong as the material itself.
Apart from allowing cost reductions through
reduced assembly times, it also allows for
functions and material combinations that
otherwise might have been problematic.

# Nanoanchors

| Key features | Non-breakable |
| --- | --- |
| | Permanent bond |
| | Lightweight |
| | Cost-effective at integrating metal and plastic resin |
| | Large choice of elastomer hardnesses |
| More | www.taiseiplas.com/e |
| Typical applications | This material can be used in mobile goods such as PDAs and computers, bicycles, automotive applications, and even large-scale components for architecture. The technology can also offer a soft texture, which is useful for impact absorption and non-slip surfaces. |

more: Aluminum 017, 042, 043, 074, 079, 080, 101, 108, 121 Injection molding 016, 020, 021, 030, 043, 052, 054, 058, 073, 090, 093, 097, 100, 114 Nanotechnology 022

# 052

# Handformed plastic

This is a material that you can readily indulge your senses in. It is a material that thinks it's a lump of plasticine. It can go from hot, soft, and sweaty to a cold and machineable hardness, and then back again. Polymorph is a plastic that is more at home in a school classroom than in a factory.

As with some of the other features in this book, there are projects and materials that challenge the perception of plastics as the material of mass production. Polymorph is a polyethylene-based ⬎ plastic that, in its method of forming, exhibits the potential to be closer to a lump of clay than to granules for injection molding ⬎ . The principle behind it is the fact that all plastics soften and become malleable when heated. What makes this material so special, however, is that it becomes malleable at a relatively low temperature, which makes it accessible on a low-tech scale.

The instructions ask that you place the granules inside a bowl of hot water or heat them up with a hairdryer until they soften and join together to form a solid mass. Once it has reached this state, you can empty the water and play with the soft but still stiff dough to your heart's content or until it cools down and starts to harden. Once this happens, you can machine it or cut it like any other plastic. When you are tired of that, you just heat it up and make something else. It brings plastic to a completely new venue; a place where it can be formed by hand in a manner that is closer to cooking than anything formed by mass production.

more: Injection molding 016, 020, 021, 030, 043, 051, 054, 058, 073, 090, 093, 097, 100, 114 Polyethylene 023, 029, 046, 093, 097, 110, 119

| Key features | **Easily formed without tooling** |
|---|---|
| | **Cost-effective** |
| | **Easily available** |
| | **Can be melted and reused** |
| More | **www.maplin.co.uk** |
| Typical applications | **The basic principle of allowing a plastic to be hand-formed means that it can be used for making prototypes, formers for vacuum-forming, and molds for casting.** |

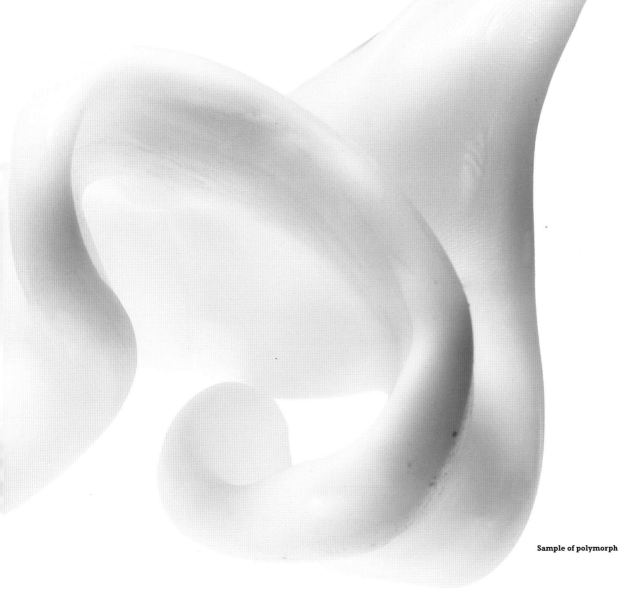

**Sample of polymorph**

# 054

Shape-memory resins ⬎ offer an invitation to push the limits of new technologies into new product areas and new functions for products. In their simplest form they are like toys, waiting for the playful experimentation that will lead to new product applications.

US based-company CRG Industries has developed a range of products based on the shape-memory effect. Veriflex™ is an advanced two-part memory resin. The effect occurs when the plastic is heated above its activation point, where it changes from being stiff and inflexible to a limp, elastic state, when it can be bent, twisted, pulled, and stretched up to 200 percent. When cooled, the plastic returns to its hardened form. It retains this shape indefinitely or until heated again past its activation point, when it returns to its original form. This process can be repeated indefinitely. The beauty of this technology is that it allows for products to be molded using conventional techniques such as injection molding ⬎ .

With the addition of a thermochromic ⬎ pigment, the resin can have extra functionality, allowing for a change of color when it has reached its activation point. This eliminates the problems of overheating the material.

# Memories are made of this

| Key features | **Can return to a programmed memory shape** |
|---|---|
| | **Can be repeatedly heated and reformed** |
| | **High stiffness** |
| | **Transportable as flat sheet** |
| | **High strength at low temperatures** |
| More | **www.crg-industries.com** |
| Typical applications | **Customizable and reusable molds; toys; architecture; furniture; deployment mechanisms; containers; shipping/packaging; actuators.** |

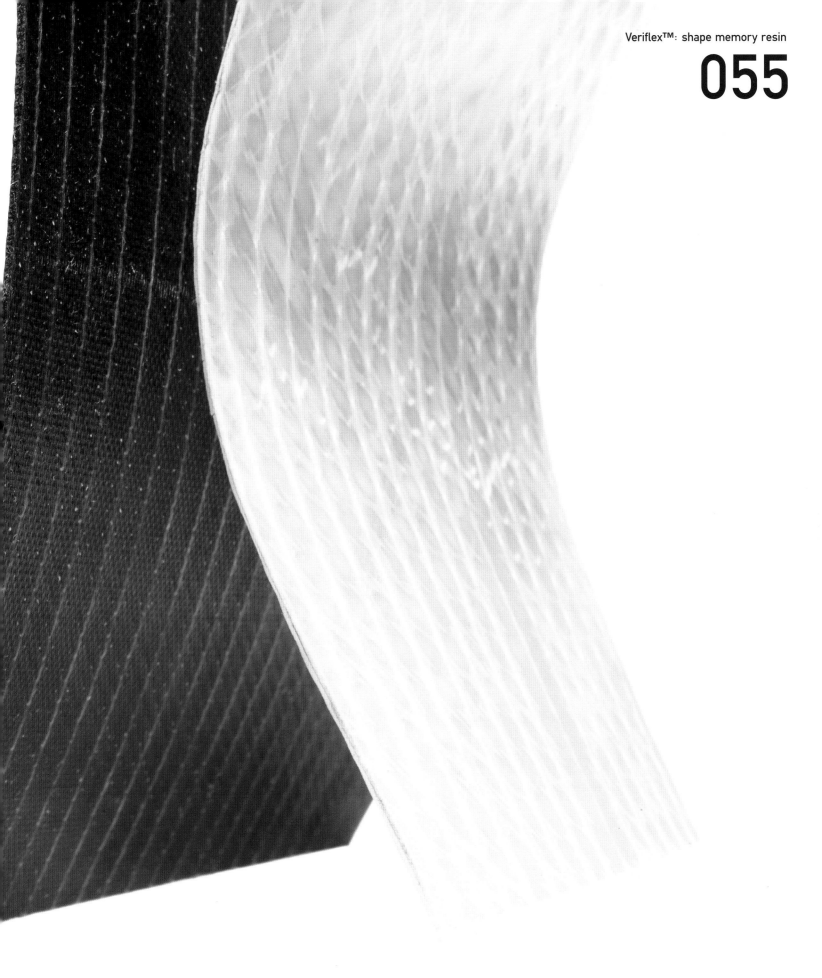

The world of shape-memory ⬂ materials is a rich and fascinating one that includes metals, plastics, fabrics, sheet materials, and now foams. Unlike the metal and plastic varieties, this foam does not use heat to return to a "remembered" profile. Instead, the material displays a much more modest effect, similar to a super-viscous liquid that allows for a slow release of an imprint that has been pushed into its surface.

This range of high-memory or shock-absorbing foams (SAFs) is available in several grades of softness and elasticity. As with viscoelastic foams, they react to gradual force with a viscous behavior, and absorb shock-like forces with elastic behavior. This behavior depends on temperature, as the material becomes more pliable when it is warm. This makes it good for mattresses, for example, as body warmth makes it more adaptable.

Shock-absorbing foam is used in orthopedic and medical mattresses and cushions to prevent bedsores. It offers support similar to gel or liquid cushions. The open-cell, porous structure also allows the material to breathe.

| Key features | Good impact absorption |
|---|---|
| | Has a small degree of memory |
| | Even distribution of pressure |
| More | www.foampartner.com |
| Typical applications | Orthopaedic bed mattresses, cushions, and shoes; sound absorption and dampening; impact absorption. Has also been used in flooring. |

# Shock-absorbing foam

# 058

EdiZONE LC is a US-based company that invents new technologies and develops them into products that are licensed to various markets. They have developed a core of three basic technologies, for which they have filed several patents, in the area of what (in layperson's terms) can be described as supergels and foams. Within this range of technologies lies three fantastically soft gel-cushioning materials: Gelastic™, Intelli-Gel™, and Floam™.

Gelastic™ is a thermoplastic elastomeric copolymer gel, so it can be extruded ⌄ , cast-, or injection-molded ⌄ . It can be formulated into a range of hardnesses and is extremely strong.

Gelastic™ forms the bases for a second technology: Intelli-Gel™. This is a semiformed material that combines the intrinsic cushioning qualities of Gelastic™ into a cell structure. This exploits the effect of column buckling to allow objects to sink into the cushion without increasing the unit pressure of the object.

Floam™, or Z-Flo™ as it is known in some markets, is the world's lightest non-gas fluid. It is used as a filling inside a plastic bladder to distribute pressure evenly in applications such as hospital bedding to prevent bedsores.

Although generally used under a secondary skin and not exposed, these plastics are some of the most seductive materials you will find. They have a beautiful tinted translucency and the feel of a slightly sticky, semiwet sponge.

Behind this rich range of sensuous playfulness lies a selection of materials with serious applications. However, EdiZONE is keen to point out that no matter how exciting the potential for the materials appears, they are strictly for high-volume mass production.

| Key features | Very stable |
| --- | --- |
| | Close to body temperature |
| | Does not alter properties with changes in temperature |
| | Superstrong |
| More | www.edizone.com |
| Typical applications | These materials are used in a wide range of cushioning products. The principle behind the materials is that they distribute pressure over the whole object that it is cushioned. Thus applications include surgical tourniquets, which are used to prevent damage to tissue while preventing excessive bleeding during surgery. Nike has used Floam™ under the name Nike Form in football and baseball cleats, snowboard boots, and skates. Other applications for Floam™ include orthopaedic support products and hospital bed mattresses for long-term care. Intelli-Gel™ is used as cushioning for the body, vibration dampening, and impact absorption. Finally, probably the most fun application is for a child's ultra-light, bouncy toy that uses the material as a molding compound. |

more: Extrusion 030, 073, 088, 090, 093, 102, 108, 114, 120 Injection molding 016, 020, 021, 030, 043, 051, 052, 054, 073, 090, 093, 097, 100, 114

# Supergels

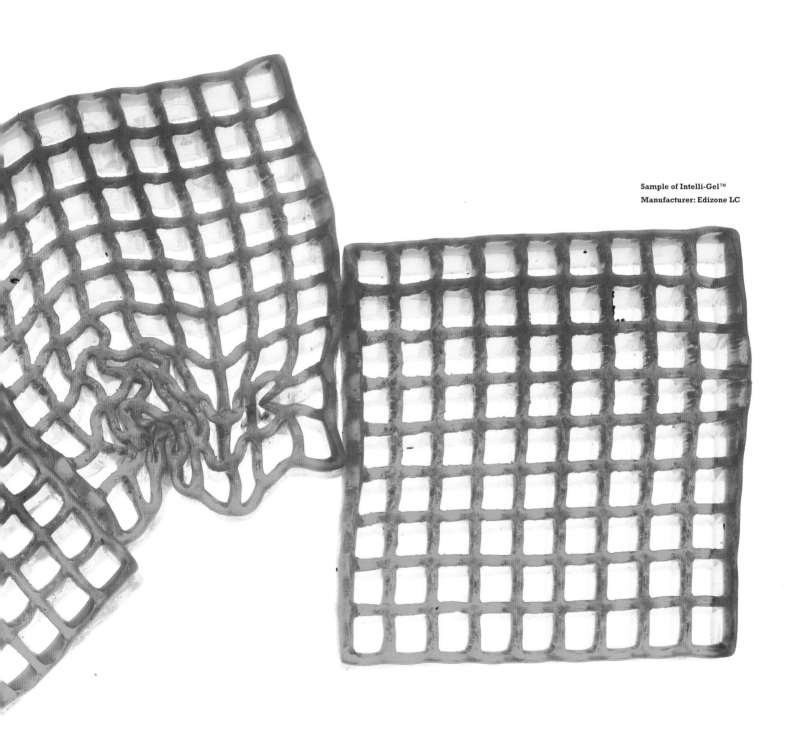

Sample of Intelli-Gel™
Manufacturer: Edizone LC

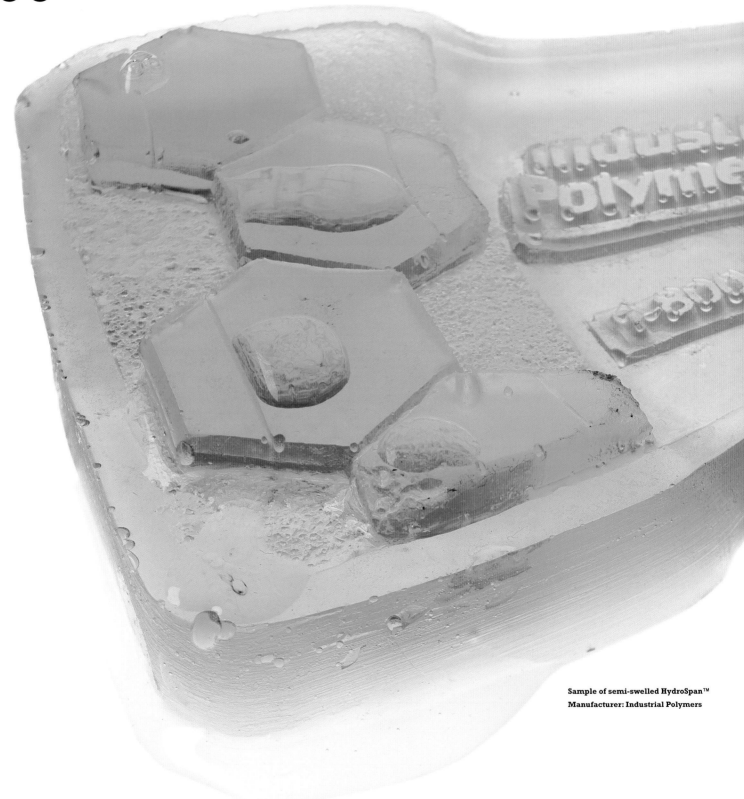

Sample of semi-swelled HydroSpan™
Manufacturer: Industrial Polymers

Grow your own products with this flexible urethane ↘ resin! HydroSpan™ is a polyurethane-based ↘ product developed by Industrial Polymers in the US. It relies on mixing together three main ingredients: hardener, resin, and plain water. As you would expect, the addition of water makes this stuff grow.

# Grow your own

The process involves mixing the resin and hardener to make your component, which can be formed in a mold. In order to enlarge the cured part, it is left in a bath of water. The length of time required for the part to soak depends on its size and thickness. The manufacturers recommend that a part with a one-inch wall thickness will require about fourteen days to expand to a maximum of 60 per cent. The product can be removed from the water at any time, depending on how much you want the piece to expand by. Once the part is fully soaked, the water is trapped inside the polymer matrix and the part feels completely dry. After several months, the material returns to its original size unless kept immersed in water. In terms of hardness, it feels like a stiff jelly, with a hardness of 45 Shore in its non-expanded state, and a slightly softer 35 Shore in its expanded state.

What this material begins to approach is the prospect of being able to grow products. At the moment, it is mainly used for model-making, where it is used in scaling up small objects. It will be interesting to see whether it has applications for more consumer-led products.

| Key features | Ability to expand |
| --- | --- |
| | Relatively cheap |
| | Can be used without any big tooling on a craft scale |
| More | www.industrialpolymers.com |
| Typical applications | This material is described by Industrial Polymers as being like a "three-dimensional copy machine" and is promoted as a modeling material. Other applications could include toys or applications that use the reverse effect, exploiting the ability of the material to shrink when the water content dries out. |

# 063 Engineering Polymers

# 064

# Silicone enhancements

Magic Trivet
Designers: Jackie Piper &
Victoria Whitbread
Manufacturer: W2

For a moment, let's ignore the fact that silicone is a high-performance, high-cost material, and instead talk about its sensuous assets as one of the most pleasurable and playful plastics. British company W2 has built a collection of silicone-based products that takes common domestic bathware, tableware, and kitchenware, and reinterprets these into cheerful, design-led forms, shapes, and textures with a close relationship to the actual functions of the products. Part of the massive attraction of these items is their soft, colored translucency, which appeals on a variety of sensuous levels. There is something hugely appealing about the sound of the table mat as it is slapped onto the table, the tough sponginess of the tea-light holder, and the misty color of the dish.

Utilizing the soft, gel-like quality of silicone, the W2 products exploit specific aspects of the material. The Magic Trivet utilizes the supreme heat-resistance of silicone combined with a thermochromic ↘ additive to produce a product that changes color according to the heat of the dish. The kitchen suckers use the suppleness of the material, while the candle holders exploit silicone's heat-resistance. All the products are an example of a celebration of a bouncy and sometimes floppy material combined with forms that make standard everyday household accessories just a little more fun.

| | |
|---|---|
| Dimensions | **230mm x 330mm** |
| Key features | **Floppy** |
| | **Bouncy** |
| | **Heat- and flame-resistant** |
| | **Easy to color** |
| | **UV-resistant** |
| | **Food-safe** |
| | **Chemically inert** |
| More | **www.w2products.com** |
| | **www.primasil.com** |
| | **www.gesilicones.com** |
| Typical applications | **Keypad elbow rests; oven door seals; breast implants; baking trays; surgical equipment; high temperature sealants; baby teats. Silicone is also the material of silly putty.** |

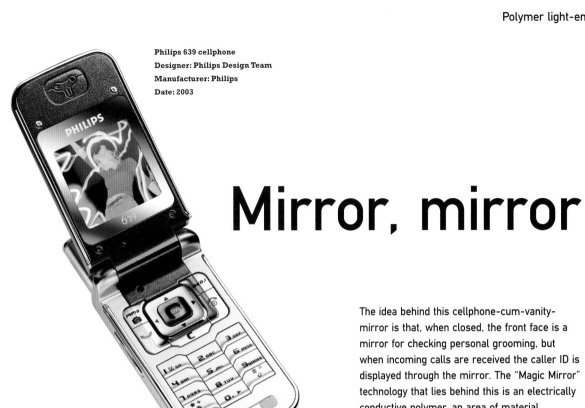

**Philips 639 cellphone**
**Designer: Philips Design Team**
**Manufacturer: Philips**
**Date: 2003**

# Mirror, mirror

| | |
|---|---|
| Dimensions | **79mm x 43mm x 21mm** |
| Key features | **Requires no backlight and therefore intrinsically thin** |
| | **Lightweight** |
| | **Bright** |
| | **Clear** |
| | **Unlimited viewing angle** |
| | **High contrast** |
| | **Fast image refresh rate even at low temperatures** |
| | **Energy efficient** |
| More | **www.research.philips.com** |
| | **www.cdtltd.co.uk** |
| Typical applications | **Products using PLEDs include wristwatch televisions, flexible and formable displays, cellphones, PDAs, computers, and televisions. Large single-pixel displays can be used in lighting applications, replacing incandescent and florescent bulbs. New applications include advertising and signage, car dashboards, and instrument panels.** |

The idea behind this cellphone-cum-vanity-mirror is that, when closed, the front face is a mirror for checking personal grooming, but when incoming calls are received the caller ID is displayed through the mirror. The "Magic Mirror" technology that lies behind this is an electrically conductive polymer, an area of material research that is becoming ever more important.

Electrically conductive polymers were first discovered by accident (as with so many new materials), in the 1970s. The story is that a Japanese student from the Tokyo Institute of Technology added too much catalyst to a batch of polyacetylene. The resulting silvery film was doped with various oxidizing agents and became conductive.

Today we are just at the beginning of the full impact that this technology will have on our lives. The continuing growth in display technologies is being pushed not only by research but also by the consumer expectation that information should become available on an increasingly mobile and miniature scale. This pushes business to explore lighter, more reliable, and thinner display systems. The number of acronyms in this field is confusing, including OLEDs, LEPs, PLEDs, and PolyLEDs. All of these technologies are based on the same concept of organic electroluminescence. Philips Research has been one of the key players in developing PLED (polymer light-emitting diode) technology for more than a decade.

# 066

| Key features | |
|---|---|
| | **Cost-effective** |
| | **Easy to mold** |
| | **Easy to color** |
| | **High abrasion resistance** |
| | **Resistant to oils and solvents** |
| | **High tear resistance** |
| | **Good resistance to weathering** |
| | **High flex life** |
| | **Low coefficient of friction** |
| | **Easy to machine** |
| | **Good impact strength** |
| More | **www.wattsurethane.com** |
| | **www.polyurethane.org** |
| | **www.cue-inc.com** |
| | **www.bayermaterialsciencenafta.com** |
| Typical applications | **Polyurethanes are a highly prolific material found in many industrial and consumer applications, from wearable to heavy industry. In its cast form, its industrial applications include seals, belts, bumpers, cutting surfaces, and rollers. In consumer applications, it is used for soles of running shoes and shoe heels, fabric coatings, furniture, and as the ingredient for spandex and Lycra. It is also readily available as a molding compound and semiformed sheet, rod, and tube.** |

It is difficult to characterize some materials because they have the potential to exist in so many guises. Polyurethanes ⊻ are one of these materials, existing in forms that range from foams to liquid coatings, and from rigid super-tough moldings to floppy gels and cast, droopy, rubbery sheets. Considering this range of potential forms, polyurethanes are possibly one of the most undervalued materials for designers.

Urethanes ⊻ are one of the five major groups of polymer classifications. The others are ethylenes, styrenes ⊻ , vinyl chlorides ⊻ , and esters. Part of the reason they can be converted into so many different forms is that, like PVC ⊻ , urethanes can be produced as thermosets ⊻ , thermoplastics ⊻ , and rubbery forms. One of the largest areas for polyurethanes is in the production of foams, where they exhibit soft, spongy qualities. In their solid-cast form, they are playful, leathery, and sometimes elastic or rubber-like materials, which can easily be colored and have the toughness of metals.

In terms of abrasion resistance, they can be compared with nylon ⊻ and acetyls, and as a result are an effective replacement for rubber, metal, and other plastics in abrasion-resistant applications. In terms of flexibility and general rubberiness, they are similar to TPUs, but without the adaptability of a range of molding techniques.

# Multitalented

Samples of a range of off-the-
shelf polyurethane profiles
from Watts Urethanes

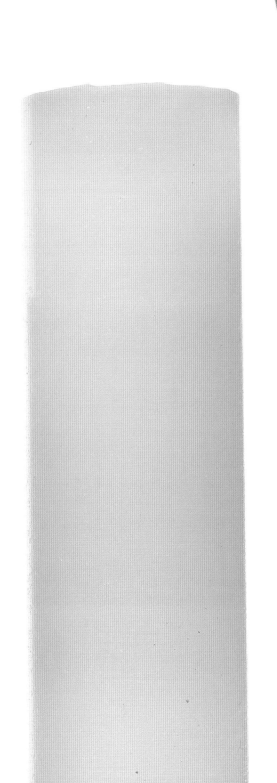

Hytrel®

# 068

more: DuPont 023, 029, 030, 071, 073, 076, 114 Hytrel 076–077
Nylon 030, 066, 071, 074, 114, 122, 124

| Dimensions | B-size chair: 1067mm x 521mm x 432mm |
|---|---|
| Key features | Combines the moldability of plastics with the flexibility of rubber |
| | Highly resistant to flex fatigue, chemicals, abrasion, and tearing |
| | Interior and exterior use |
| | Hytrel® can be blow-, injection- and rotational-molded, and extruded |
| | Breathable |
| More | www.hermanmiller.com |
| | www.quantum5280.com |
| | http://plastics.dupont.com |
| Typical applications | Hytrel® is a highly morphable material, lending itself to a range of forms that exploit its diverse properties. These include injection-molded bed springs, office furniture, and the breathable layers on antiallergenic bedding. |

Design is having to become increasingly interdisciplinary, looking beyond conventional approaches to material conventions within traditional typologies. Hytrel® ↘ is a material that lends itself to such an approach. Not restricted to being just a molding compound, it can also be tailored to create fabrics and yarns. From DuPont ↘, the company that brought us nylon ↘ in the 1930s, Hytrel® fibers have been licensed to textile company Quantum Group Inc. for use in a range of upholstery applications.

One of the most high-profile products to feature the fabric is the Aeron chair, manufactured by Herman Miller. This has become a modern-day icon for office chair design. Described by design critic Deyan Sudjic as the "stealth bomber of chairs," it uses a stack of engineering plastics, including Hytrel®. It becomes a case study for how engineering plastics can be used for a host of structural applications.

As part of the brief to encompass pioneering ergonomics, the chair is designed to fit around the infinite range of human shapes and postures, taking into account the range of activities that take place during the day. The open-celled, breathable Hytrel® fabric that is used for the back and seat upholstery offers the design a sag-free, cushionable surface that replaces traditional foam.

Aeron chair
Designers: Bill Stumpf and Don Chadwick
Manufacturer: Herman Miller
Date: 1994

# New cushioning

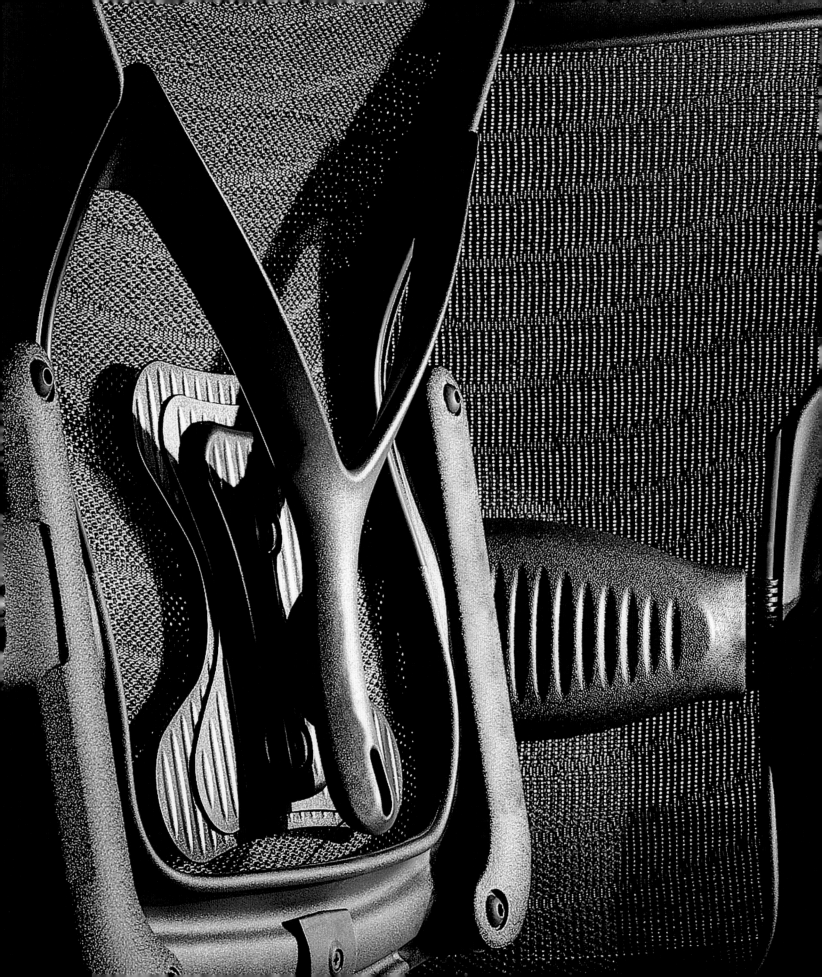

| Key features | Weatherable |
| --- | --- |
| | Colorfast |
| | Impact-resistant |
| | Resistant to environmental stress cracking |
| | Easy to process |
| | High heat resistance |
| | High gloss |
| | Chemical-resistant |
| More | www.plasticsportal.com |
| Typical applications | This is a material that is able to give a long service life for products that will live outdoors. Applications can mainly be divided into three main markets: automotive, building/construction, and leisure. Specific products include garden furniture; sprinklers; garden lights; extruded glazing; and satellite aerials. Other applications include microwave ovens, vacuum cleaners, and washing machines. |

Welcome to the world of terpolymers ⌄ : a place where the best bits of three monomers are blended to form a completely new material with a stack of new potential uses. To give a little background, one of the most prevalent terpolymers is ABS ⌄ , a material known for its toughness and ease of production. Compared with ABS, ASA ⌄ is probably less recognized but also has many uses.

ASAs can be summarized as a tough, hardy, robust, and durable material. Based on acrylonitrile ⌄ , styrene ⌄ , and acrylate, ASA resins have properties similar to ABS but with a rubber taking the place of the butadiene that exists in ABS. This rubber adds resilience to UV and oxygen degradation, which marks the main distinction and makes it a valuable material for outdoor use. It is this resistance to chemicals and impact, and its ability to hold colors, which mean that ASAs should be a main consideration for external, weatherable applications.

Oral-B CrossAction® Power electric toothbrush
Manufacturer: Braun
Designed:2004

# The outsider

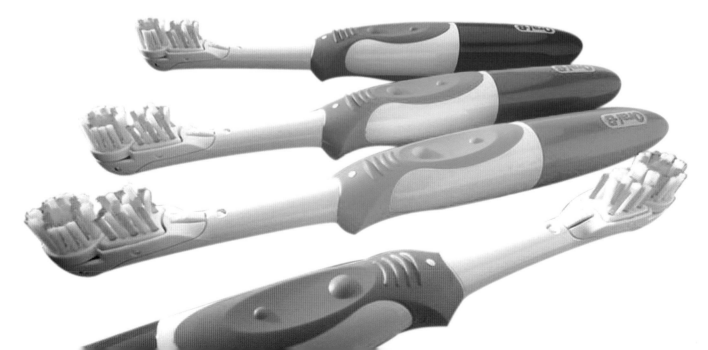

**Parton Swiss Army Knife**
**Designer: Victorinox**
**Manufacturer: Victorinox**
**Originally designed: 1897**

In the 1930s, nylon ↘ (or polyamide, by its technical name) was one of the first engineering polymers ↘ to be discovered. Developed by DuPont ↘ , nylon has now become part of common language. According to legend, the name is an amalgamation of New York and London, the two cities where nylon was discovered simultaneously. Although existing in many forms, the properties across the family of resins vary due to the number of different formulations. However, nylon is characterized by strength, toughness, and stiffness.

# Strength, toughness, and stiffness

The Swiss army knife provides the perfect symbol for this tough plastic, and is perhaps the perfect match of product with material. Both product and material are icons and both are known for their ruggedness, with different versions and slight modifications and additions available. Two of the most widely used versions of nylon are nylon 6 and nylon 66. As a molding compound, it exhibits several superior qualities. When reinforced with glass, nylon becomes an even harder material. By itself, it is not one of the strongest engineering plastics, but has a natural waxy surface and the added advantage of being able to be cast, allowing for components several centimeters thick.

| | |
|---|---|
| Dimensions | **91mm x 10mm** |
| Key features | **Slippery** |
| | **Good impact resistance** |
| | **Tough** |
| | **Stiff** |
| | **Wear-resistant** |
| | **Able to achieve a high gloss** |
| | **Available clear or opaque** |
| More | **www.emsgrivory.com** |
| Typical applications | **Well known for being able to be drawn into silk-like fibers for clothing, nylon has a variety of uses and forms, including glass-reinforced molding compounds. Other applications include rope, engineering applications, and nutcrackers. Nylon is useful under the hood of cars, where its performance characteristics make them suitable for a variety of components. Low friction makes it useful for bearings, cams, and gears.** |

more: DuPont 023, 029, 030, 068, 073, 076, 114 Engineering polymers 021, 023, 073, 076, 080 Nylon 030, 066, 068, 074, 114, 122, 124

↑

# Surgical
# precision

An operating room requires materials and products that demonstrate real strength. Stainless steels ⬂ have been a traditional and common material in the medical arena for some time; their corrosion resistance and general high wearability have been unsurpassed. They are, however, limited on many levels. Enter polyphenyl sulfone (PPSU) plastics: thermoplastics ⬂ that are characterized by their transparency, rigidity, and ability to remain stable at high temperatures.

This range of materials is designed for harsh environments; they can withstand temperatures of up to 405°F (207°C) while maintaining their strength. In the medical industry, which requires products to be repeatedly sterilized, PPSUs are engineered to withstand the sterilization process and highly aggressive cleaners. In their natural form, PPSUs are also stable and self-extinguishable, whereas other materials need modifiers to offer this quality. PPSU resins can be formed using standard plastic molding techniques, or they can be machined.

This kind of material demonstrates the advancement of plastics into more extreme environments.

**Sample plaques of PPSU supplied by Solvay Plastics**

| Key features | |
|---|---|
| | **High temperature resistance** |
| | **Chemical-resistant** |
| | **High-impact strength** |
| | **Tough** |
| | **Transparent** |
| | **Rigid** |
| | **Biologically inert** |
| | **Easily processed** |
| | **Approved for food contact and potable water use** |
| More | **www.solvayadvancedpolymers.com** |
| | **www.solvayplastics.com** |
| Typical applications | **A large number of applications are in the medical industry, such as instrument trays, surgical equipment handles, and components that require products to be continually sterilized and to withstand being thrown around. Other applications where products require sterilization and high wear include canteen trays, electrical/electronic components, wire insulation, and parts for aircraft interiors.** |

more: Stainless steel 038 Thermoplastics 046, 066, 080, 126

# The contender

There are many materials that have applications and formulations that are so diverse it is impossible to categorize them in a straightforward way. Surlyn® is one of these. It is one of the big engineering polymer ⟶ brands from DuPont ⟶ . An Ionomer resin, Surlyn® has several high-performance characteristics that make it valuable in a range of applications. It appears in the translucent clarity of the thick, injection-molded ⟶ walls of a perfume bottle, in squeezable, soft, extruded ⟶ shampoo tubes, and even in the tough, resilient skin on golf balls.

A big marketing drive from plastic producers often results in the benefits of some plastics over other materials being more widely recognized, offering a rationalization of existing materials and components. For example, plastics such as polypropylene ⟶ are now widely known to be able to integrate live hinges within their moldings while avoiding using secondary materials. On the other hand, take the case of glass, which, although it can be a super-cheap raw material, can't be formed or molded into complex shapes as easily as plastic.

How the many, diverse advantages of Surlyn®, which exist in a range of applications, are communicated to designers is a problem for the brand owners. It might be simplest to label it as a tough, crystal-clear material with a thousand uses waiting to be explored.

Surlyn® Discovery Kit designed to convey the sensorial characteristics of Surlyn®
Designer: DuPont

| Dimensions | Each unit is 100mm long |
|---|---|
| Key features | Outstanding impact toughness |
| | Abrasion-resistant |
| | Scuff-resistant |
| | Chemical-resistant |
| | Water-clear transparency and clarity |
| | High melt strength |
| More | www.dupont.com/industrial-polymers/surlyn/index.html |
| Typical applications | Dog chews, as an alternative to glass in perfume bottles, the skins of golf balls, hockey helmets, footwear, bodyboards, ten-pin bowling pins, tool handles, glass coating, ski boots, laminating film, automotive fascias, and bath and kitchen door handles. |

more: **DuPont** 023, 029, 030, 068, 071, 076, 114 **Engineering polymers** 021, 023, 071, 076, 080 **Extrusion** 030, 058, 088, 090, 093, 102, 108, 114, 120 **Injection molding** 016, 020, 021, 030, 043, 051, 052, 054, 058, 090, 093, 097, 100, 114 **Polypropylene** 017, 018, 036, 043, 045, 088, 093, 119, 125

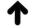

# Heavy betting

To really appreciate the value embedded in this material, you need to feel its weight in your hands. Visually, it looks like a typical plastic: a high-gloss surface on a complex molded shape. But here lies the deception, because, unlike a typical plastic, high-gravity plastics are as heavy as a piece of steel ⟱. To put its weight into relative terms, high-gravity plastics can have densities up to 15g/cc. This is quite impressive when compared with aluminum ⟱, which has a specific gravity of 2.7, or steel, at 7.6g/cc.

At first, the idea of deliberately making a plastic heavy seems to contradict one of the advantages that plastic has over metals. Traditionally, one of the key benefits to using plastics is their ability to be molded into complex shapes and to be relatively lightweight, so why would you use a material that is heavier than necessary? The answer lies in the unique potential to create a combination of moldability and weight: look at the list opposite for some typical applications.

HGPs get their weight from the addition of either mineral or metal fillers, depending on the amount of weight you want to create. As a guide, metal fillers give a darker range of colors than the naturally lighter minerals. As with high-performance engineering materials such as the more traditional, weighty, glass-filled nylon ⟱, HGPs are relatively expensive.

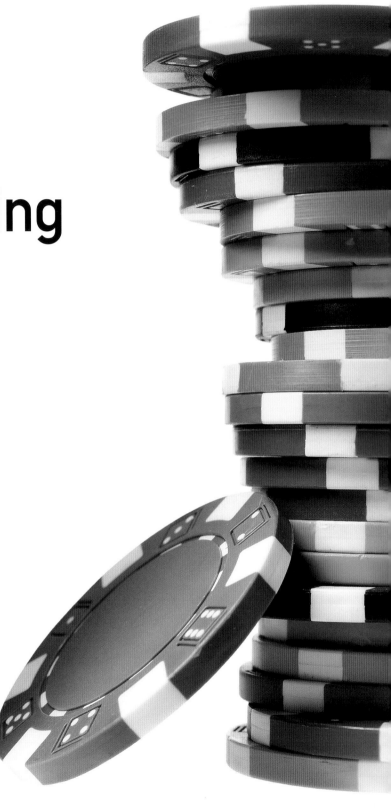

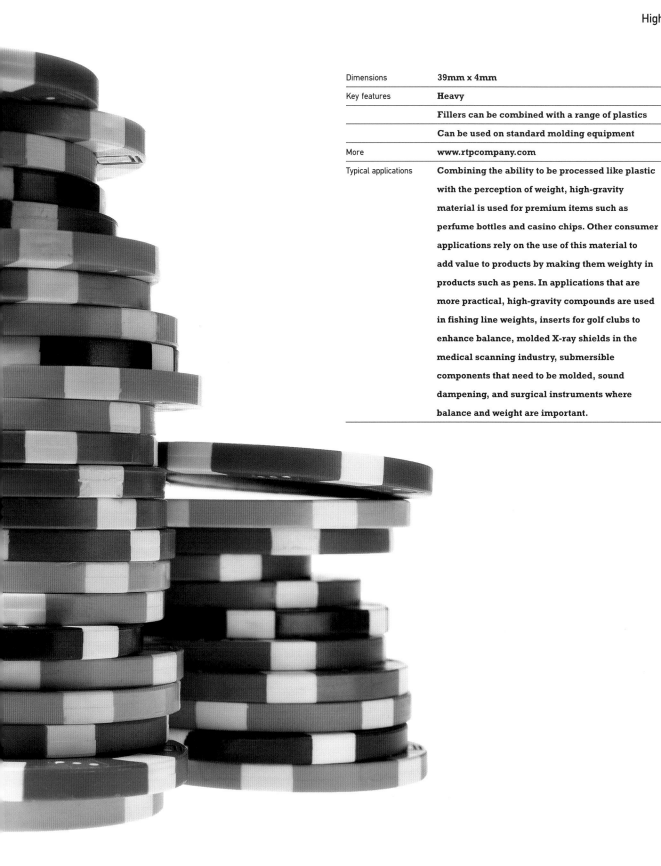

| Dimensions | 39mm x 4mm |
|---|---|
| Key features | Heavy |
| | Fillers can be combined with a range of plastics |
| | Can be used on standard molding equipment |
| More | www.rtpcompany.com |
| Typical applications | Combining the ability to be processed like plastic with the perception of weight, high-gravity material is used for premium items such as perfume bottles and casino chips. Other consumer applications rely on the use of this material to add value to products by making them weighty in products such as pens. In applications that are more practical, high-gravity compounds are used in fishing line weights, inserts for golf clubs to enhance balance, molded X-ray shields in the medical scanning industry, submersible components that need to be molded, sound dampening, and surgical instruments where balance and weight are important. |

# 076

# Engineering your comfort

Hytrel® ⬎ is one of the main engineering polymers ⬎ from DuPont ⬎ . TPEs (thermoplastic elastomers) ⬎ , as with many other plastics, can be formed into many varieties and forms. From its use as a fiber in industrial textiles, to a replacement metal that exploits its natural springiness, Hytrel® crops up in many unexpected places.

What is particularly interesting—even rebellious—about this design for a pillow by San Francisco-based designers Maaike Evers and Mike Simonian is that they take the material out of the traditional context of engineering and into the arena of soft furnishings, challenging the possibilities of plastics in a domestic environment.

The pillows mark a new territory for this prolific material, exploiting its combination of the flexibility of rubbers with the strength and processability of plastic. It also integrates mold-in snap fittings and variable wall thickness, and can withstand repetitive bending. The reduction of mass and surface area also provides an efficient form. This not only results in a long-lasting, durable, and easy-to-clean product, but also provides a new visual language for a very traditional product typology.

**Thermoplastic Pillow Collection**
**Designers: Maaike Evers and Mike Simonian**
**Manufacturer: Concept only**
**Date: 2004**

more: DuPont 023, 029, 030, 068, 071, 073, 114 Engineering polymers 021, 023, 071, 073, 080 Hytrel 068–069 TPE 119

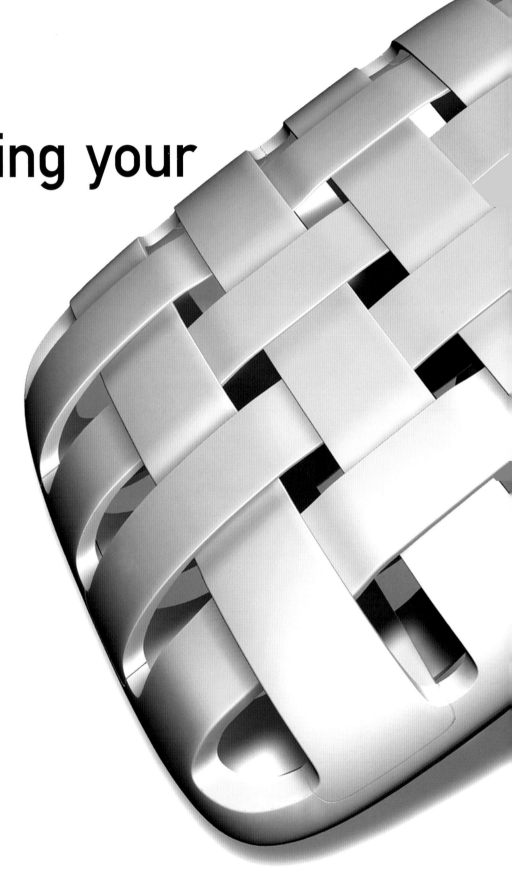

| | |
|---|---|
| Dimensions | **350mm x 350mm x 80mm** |
| Key features | **Combines the moldability of plastics with the flexibility of rubber** |
| | **Highly resistant to flex fatigue, chemicals, abrasion, and tearing** |
| | **Interior and exterior use** |
| | **Can be blow-, injection-, and rotational-molded, or extruded** |
| | **Breathable** |
| More | **www.mikeandmaaike.com** |
| | **plastics.dupont.com** |

Typical applications

**Hytrel® is a highly morphable material, lending itself to a range of forms that exploit its diverse properties. For example, it has been used as an injection-molded bedspring, exploiting its strength and flexibility; in the Herman Miller Aeron® office chair (see page 68), which features Hytrel® fibers to replace foam cushioning in the open structured seat and back panels; and in a breathable layer on bedding such as antiallergenic mattresses, quilts, and pillow covers.**

In metallurgists' terms, the words hardness, toughness, and strength have very specific meanings. Toughness is defined as the ability of a material to absorb energy by plastic deformation—an intermediate characteristic between softness and brittleness. The toughness of a product is characterized by impact strength and is only partly dependent on the material: other contributing factors include the way the component is molded, wall thicknesses, and part geometries. There are also factors such as the working temperature of the product and whether it is reinforced, as many materials can be made using various fibers.

However, there are materials that are tough due to their inherent strength. One of the most common and toughest engineering plastics is polycarbonate ↘, which combines this toughness, stiffness, and strength with a superb optical clarity. Discovered in 1953 and commercialized later that decade, polycarbonate was originally used for electrical devices before being used for glazing.

In terms of clarity, polycarbonate can be compared with polystyrene ↘, SAN ↘, acrylic ↘, and PET ↘. For its toughness, it can be compared with acetals ↘. One of the uses of polycarbonate resins is in blending with other plastics, such as ABS ↘ and PBT ↘. The toughness of this widely used plastic is put to good use in the everyday application of this children's night-light.

**Beba children's night-light**
**Designer: Miriam Mirri**
**Manufacture: Alessi**
**Date: 2004**

more: **ABS** 021, 036, 041, 047, 070, 101, 115 **Acetal** 021, 114 **Acrylic** 038, 040, 041 **PBT** 120 **PET** 018, 038, 097, 120, 121 **Polycarbonate** 017, 022, 036, 038, 050 **Polystyrene** 038, 040, 042, 047, 093 **SAN** 036, 038, 040, 047

# Inherent toughness

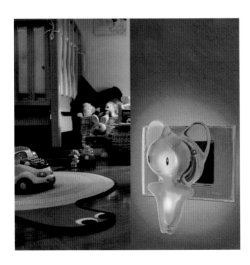

| Dimensions | 125mm x 80mm x 95mm |
|---|---|
| Key features | **Tough** |
| | **Stiff** |
| | **Strong** |
| | **Water-like transparency** |
| | **Flame-resistant** |
| | **Excellent dimensional stability, even at high temperatures** |
| | **Good heat resistance up to 125°C** |
| | **Recyclable** |
| | **UV-stable** |
| | **Non-toxic** |
| More | **www.alessi.com** |
| Typical applications | **The compact disk and DVD industry is completely reliant on polycarbonates. Other applications include visors and safety helmets; eyewear; kitchen containers; computer housings; architectural glazing; cellphone housings; packaging; automotive headlamps; shatter-resistant waterfountain bottles; riot shields; and vandal-proof glazing. Polycarbonates are also used in the electrical and electronics industries.** |

Regarded as one the highest-performance polymers available, polyetheretherketone (PEEK) ↘ has a long list of assets that make it attractive for a range of demanding applications. Characterized by high stiffness, heat resistance, and strength, PEEK demonstrates its superior nature in applications to replace aluminum ↘ and other metals in the aerospace industry.

Although there are many other plastics with these high-performance traits, the distinguishing benefit of PEEK is that it is melt-processable, which means that it is able to be formed using conventional molding machinery. This is not always the case with other high-performing plastics. It is one of the purest and most stable of polymers, which means that it does not contain additives that may be released during heating in the molding process. It is also implantable for use as body-part replacements in the medical industry.

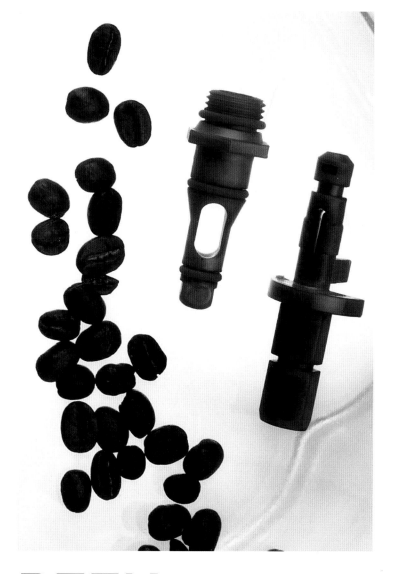

PEEK coffee maker: boiler-pin and steam faucet
Manufacturer: Victrex

| Key features | Easy to process |
| --- | --- |
| | Tough |
| | Scratch-resistant |
| | High-temperature-resistant |
| | Stiff |
| | Fatigue-resistant |
| | Chemical-resistant |
| | Radiation-resistant |
| | Can be processed by standard plastic processing methods |
| More | www.victrex.com |
| | www.invibio.com |
| Typical applications | There aren't many applications where you would actually see this material and be able to admire its properties. Its high cost means that applications tend to be limited to engineering, where it is used for bearings, bushings, as a coating, and for electrical connectors. PEEK is also a high-performance protective tubing and is available in glass- or carbon-filled grades. |

# PEEK performance plastic

more: Aluminum 017, 042, 043, 051, 074, 080, 101, 108, 121 PEEK 080

# 080

# Metal replacement

Material families such as metals, ceramics, and plastics are always trying to find new markets in each other's industries: ceramics that can be molded like plastics; engineered woods that are as dense as aluminum ⌄ ; and now plastics that are trying to outperform metals. The advantage of plastics is quite evident: easy manufacturing in a virtually infinite range of shapes, colorability, and corrosion resistance. However, plastics traditionally fall short on the qualities of stiffness, strength, and hardness.

Parmax® addresses these shortfalls. It is a high-tech, high-performance engineering polymer ⌄ that is part of the family of metal-replacement plastics engineered to outperform similar plastic rivals such as PEEK ⌄ in strength. Unlike other superstrong plastics, Parmax® has no other reinforcing binders. Nonetheless, the manufacturers claim that Parmax® is two to three times stronger and stiffer than conventional unfilled thermoplastics ⌄ .

The stiffness, strength, and hardness of Parmax® can be seen when you hold a sample in your hand: its high density and hardness more closely resemble a chunk of aluminum than plastic, although its shiny surface leaves no doubt that it definitely is a plastic.

| | |
|---|---|
| Key features | **High strength and stiffness** |
| | **Excellent scratch resistance** |
| | **Good friction and wear properties** |
| | **Excellent chemical resistance** |
| | **Exceptional low-temperature performance** |
| More | **www.mptpolymers.com** |
| Typical applications | **The low weight of Parmax® self-reinforced polymers makes them ideal as a metal replacement in weight-sensitive applications. Components can be compression-molded, extruded, cast, foamed, injection-molded, and machined. This range of manufacturing potential makes it useful in a variety of commercial engineering applications, from films and coatings to aircraft interiors and surgical instruments.** |

**Nut and bolt made from Parmax**
**Manufacturer: MPT Polymers**

more: Aluminum 017, 042, 043, 051, 074, 079, 101, 108, 121 Engineering polymers 021, 023, 071, 073, 076 PEEK 079 Thermoplastics 046, 066, 072, 126

083 Green Plastics

084

Naturally wearing

| Key features | Superior strength, as with most composites |
| --- | --- |
| | Natural fibers create a unique esthetic |
| | Surface is enhanced with age, as with wood |
| | or leather |
| More | www.studiorob.co.uk |
| Typical applications | Scratches, knocks, and chips are hidden by the |
| | richness of this naturally decorative material. |
| | This makes it suitable for anything that has a lot of |
| | "people contact," including flooring and furniture, |
| | and personal products, such as briefcases. |

Although it is engineers and scientists who develop new formulas for plastics, it is often left to designers to redefine plastics in the cultural context. London-based designer Rob Thompson has contributed to the evolution of plastics with his "material memories" project. Dealing with the visible signs of age on a product's surface, Rob has looked at how composite materials can be given the capacity to enhance emotional bonding between product and user.

He explains, "To achieve this, I combined plastic with natural fiber-based materials such as straw, wood shavings, feathers, hemp, and recycled newspaper. This resulted in new and exciting composites that utilize the versatile and moldable qualities of synthetic materials with the ageing, esthetic qualities of natural fibers."

There are many ways in which these products can be adapted in the future. The look of the material will change as different forms of recycled paper are added, such as used billboards. As the paper and typefaces of newspapers change, so will the composite.

The real benefit of these composites and products is that they look to the future, as opposed to being nostalgic. They are sensitive to our desire for material memories in the fast-developing and transient world of the commodities that surround us.

Material Memories Stools
Designer: Rob Thompson
Client: Self-initiated project
Date: 2002

# Stars in stripes

My definition of "new materials" includes
those that have been given new potential by
being employed in new territories. It's always
exciting to talk about the use of completely new
substances and technologies, but there is as
much invention and ingenuity in finding new
applications for an old substance as there is in
developing a new one. This discussion of reuse
is even more important than the area of
emerging technologies and materials because
it includes sustainability.

Cellulose acetate (CA) has two of these criteria:
the first lies in the fact that cellulose ⬎ is starch
and, as a result, is derived from a rapidly
renewable source rather than the oil-based
feedstock from which most other polymers are
derived. Second, although it is an old material,
it is, thanks to Eastman Chemicals ⬎ , being given
a new lease of life in the design industry.

Originally a replacement for celluloid—the trade
name for cellulose nitrate—due to its lower
burning rate, CA has been used since the 1930s
for a variety of products. As one of the oldest
forms of mass-producible plastics, it has been
superseded by many newer advances. However,
the Collective Vision exploration by designers at
IDEO resurrects the potential of this material.
Using two of Eastman's staple materials—
copolyester ⬎ and cellulose—the concepts within
this collection highlight the contemporary benefits
of a material that is ancient in terms of plastics.

| Key features | Warm to the skin |
| --- | --- |
| | Very tough |
| | Derived from a renewable source |
| | Self-polishing |
| | Available in intense or translucent colors |
| | Tactile surface |
| | Can be worked or polished by hand |
| | Easily molded |
| More | www.ideo.com |
| | www.eastman.com |
| Typical applications | Exploiting its many warm, friendly properties, CA is used in all sorts of "close to the skin" applications, including toothbrushes, tool handles, hairclips, cutlery handles, toys, playing cards, dice, screwdriver handles, and goggles. |

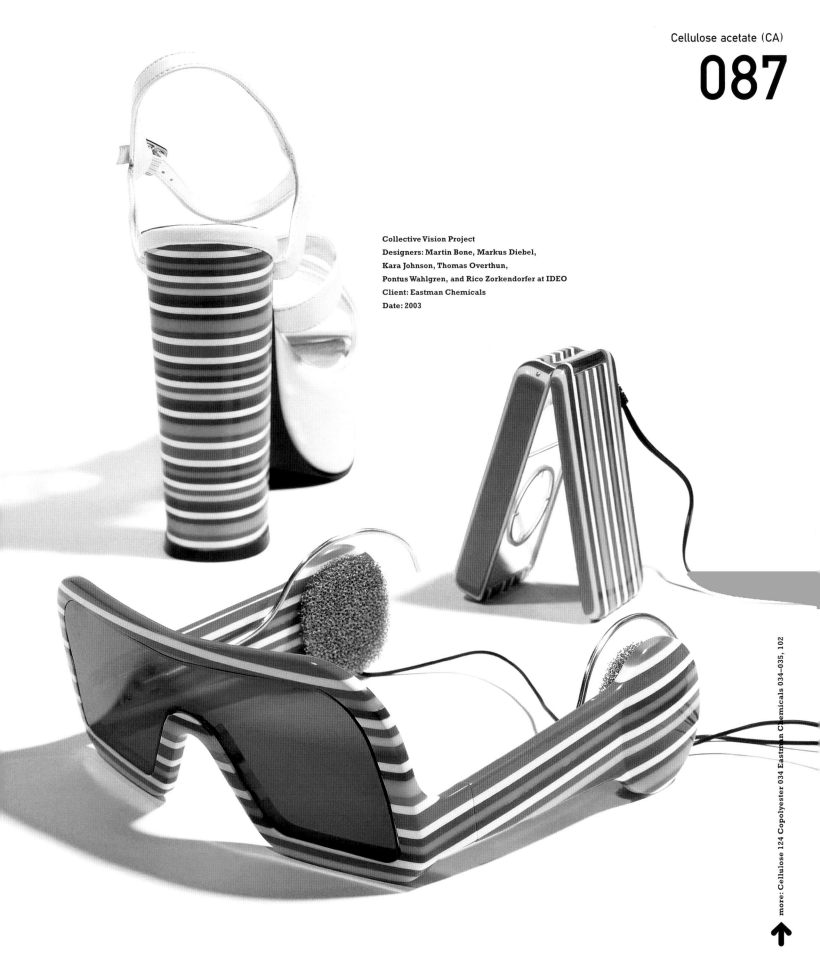

**Collective Vision Project**
**Designers: Martin Bone, Markus Diebel,**
**Kara Johnson, Thomas Overthun,**
**Pontus Wahlgren, and Rico Zorkendorfer at IDEO**
**Client: Eastman Chemicals**
**Date: 2003**

more: Cellulose 124 Copolyester 034 Eastman Chemicals 034–035, 102

# 088

Industrial netting is a highly underrated semiformed material. It has many advantages: it is lightweight, strong, and uses very little material. It is for these reasons that nets are used in everything from packaging oranges to protecting your bottles in duty-free.

In terms of forming, it is extruded ↘ into tubes. As with many types of netting, the rhomboidal structure allows for a natural ability of the net when stretched to conform to the most economical shape, wrapping and hugging itself around items of any shape.

In this packaging design for British John Lewis, the netting was used to overcome the problem of how to enclose a set of large, domestic cleaning products in a package that was not excessive in scale, cost, or materials. The products' retail price was a major issue, as these items were designed to appeal to people setting up their first home. The simple color and esthetics of the products were also selling points, as was the ability to see them in the package. Traditional board materials were rejected due to the cost and quantity of material that would have been needed for each set. However, the combination of the cardboard tray and polypropylene ↘ netting provided a strong, cheap, and transparent alternative that allowed for branding, and which also allowed for an integral handle to carry the products with.

# Form-hugging

Packaging for Essentials cleaning products
Designers: Pearce Marchbank and Chris Lefteri
Client: John Lewis Partnership
Date: 2005

more: Extrusion 030, 058, 073, 090, 093, 102, 108, 114, 120 Polypropylene 017, 018, 036, 043, 045, 073, 093, 119, 125

| Key features | Contents are exposed but still protected |
| --- | --- |
| | Good strength-to-weight ratio |
| | Can fit any form |
| | Available in a range of diameters |
| More | www.tenax.net |
| Typical applications | This grade of polypropylene net is used for all types of restraining nets for industrial and horticultural applications, including Christmas-tree netting, and nets for pallet loads. Other nets are used for protecting industrial components, for packaging of fruit and vegetables, toys, and even as sponge nets. |

# Compostable

| | |
|---|---|
| Dimensions | **80mm x 40mm** |
| Key features | **Completely biodegradable in different environments** |
| | **Compostable in soil, fresh water, and salt water** |
| | **Easy to form using traditional plastic techniques** |
| | **Printable using normal inks and printing techniques without the need for crown treatment** |
| | **Intrinsically antistatic** |
| | **Sterilized using gamma rays** |
| | **Can incorporate masterbatches** |
| More | **www.materbi.com** |
| | **www.pandoradesign.it** |
| Typical applications | **Food packaging; toys; pens; cotton buds; diapers; catering products; compost bags; dog chews; biodegradable shopping bags; extruded nets for food packaging; kitchen paper rolls; and stationery items such as rulers and pencil sharpeners. Mater-Bi™ can also be converted to foams.** |

Along with nanocomposites, environmentally friendly products are one of the fastest-growing areas within plastics. The industry is filled with examples, such as the recycled plastic products of Smile Plastics Ltd ↘ , and the recycled stationery produced by Remarkable Pencils Ltd.

Bioplastics are another aspect of this movement towards environmental credibility. They provide a perfect cycle of materials. The cycle starts with cornstarch. This is transformed into pellets, processed into products, used by consumers, and then returned to the ground without releasing pollutants.

Mater-Bi™ is one such cornstarch-based bioplastic, developed by the Italian company Novamont, that responds to the growing demand for materials that do not have a harmful impact on the environment. It is a plastic derived from a rapidly renewable source, and it is both biodegradable and compostable.

In this application for a new type of eating utensil, the economy of material is also applied to the economy of function: the spoon and fork are combined in the same product. Within the scale and thin wall section, the material is slightly springy and has a lustrous tactile quality—it feels more like a natural material than a traditional plastic high-sheen product. Although it has this slightly soft feel, it is also pretty tough, which has led to one of its many other applications: dog chews!

**Moscardino disposable spoon/fork made from Mater-Bi™ plastic**
**Designers: Matteo Ragni and Giulio Iacchetti**
**Manufacturer: Pandora Design**
**Date: 2000**

more: Smile Plastics Ltd 94–95

# 090

↑

# Soluble packaging

One of the disadvantages of plastics is that they have an image problem, particularly in terms of environmental friendliness. We can all summon up images of tons of plastic waste piled high in anonymous landfills. However, there are many case studies of new materials that are overcoming the major issue of waste disposal. One of the hottest topics in discussions about environmental issues is materials that degrade, whether through solubility, biodegradation, or photodegradation.

Polyvinyl alcohol (PVA) has been around for some time, and today is commonly seen in the form of detergent dispensers for washing machines. But designers have yet to embrace the possibilities of this valuable technology whereby products dissolve in water, having performed their primary function, and leave nothing behind.

Although most of the existing applications are in packaging, there is a constant stream of new developments within water-soluble and other degradable materials. There is no reason why they can't be used for injection-moldable ↘ or extruded ↘ products.

This image of cradlewrap illustrates an application for PVA as a packaging material. It combines a highly impact-resistant structure with a PVA material, which either dissolves in water or is compostable. Taking less than a minute to dissolve in warm tap water, it disintegrates from a thin plastic material to a slippery gel that consists of nothing but carbon dioxide and water.

| Key features | Biodegradable |
| --- | --- |
| | Environmentally sound |
| | Non-hazardous |
| | Solubility can be controlled by hot or cold water |
| | Good resistance to chemicals |
| | Non-toxic residue after it dissolves |
| | Can offer good degree of transparency |
| | Good tensile strength and elasticity |
| | Printable |
| | Offers user-controllable solubility |
| More | www.amtrexintl.com |
| | www.aquasol-ltd.com |
| | www.stanelco.devisland.net |
| | www.stanelcoplc.com |
| Typical applications | Applications range from the soap containers for washing machines to edible films. Industrial uses include pharmaceuticals, washaway labels, hospital laundry bags where contaminated clothes can be disposed of without human contact, and public toilet-seat protectors. It is also being explored as an alternative to traditional gelatin-based pill capsules, veterinary applications, and plant pesticide capsules that dissolve to release the pesticide into the soil. |

CradleWrap water soluble packing material

# 092

The technology that enables us to manufacture products has developed over thousands of years, allowing evolutions of new methods and techniques and the introduction of completely new ways to make our objects quicker, cheaper, and in larger volumes. It is only recently that we have had to consider the other side of the coin, which is what happens when we throw these objects away. It is the realization that we have become too good at making things faster and cheaper that has prompted research into ways in which materials can have their lives extended—or eradicated.

# Wash it away

At the very heart of the definition of plastics is the ability of materials to be easily transformed from a one state, usually liquid, to another. In virtually all cases, this transition is used to make parts. Plantic® demonstrates the increasing number of applications where the process of transformation is reversed and is used to destroy and safely dispose of the product. Plantic® is as versatile as traditional plastics; it also looks and feels the same. The difference lies in the fact that Plantic® is made from starch, requiring less than a cob of corn to make a chocolate box tray, and, importantly, it dissolves in water.

The makers, Plantic Technologies, relate the biodegradability rate of the plastic with that of household food scraps. Plantic® can be put into the garden composting heap or simply thrown in your trashcan, where you can be assured that it will disappear forever.

| Key features | **Biodegradable** |
| --- | --- |
| | **Environmentally sound** |
| | **Non-hazardous** |
| | **Non-toxic residue after it dissolves** |
| More | **www.plantic.com.au** |
| Typical applications | **A large market for Plantic® appears to be for trays in the confectionery industry. However, Plantic® can be used to injection-mold just about anything, from children's toys to car parts.** |

Sample of Natraplast® wood-plastic composite

What happens if you combine the handiness of chopping up a lump of wood with the economy of an industrially produced, premolded shape? The answer lies with the many companies that are now producing composite materials made of wood fibers and plastics. The idea of combining plastics and wood fibers is not new—Rolls Royce used composites as early as 1916. However, with our urgent need to re-examine how we use our resources, and with research into sustainable materials and composites, such materials are seeing a massive renewal of interest.

There are a number of benefits to using wood-plastic composites, the main one being that they combine the workability of timber with the processability of plastics. They can be injection molded ↘ , rotationally molded ↘ , and, more popularly, extruded ↘ . This can be achieved using a number of plastics, including polystyrene ↘, polyethylene ↘ , and polypropylene ↘ .

Wood-plastic composites also reduce the amount of raw plastic material that is required to produce a component. They also allow for a reduction in cycle times for injection molding due to the part cooling faster and having less shrinkage (and therefore higher tolerances).

Natraplast® is one of the many products that combine these two materials. It is a material that bridges plastic mass production and handworking, while also providing an oaty, natural surface alternative to the traditional plastic surface esthetic.

| Key features compared to wood | Increases dimensional stability |
| --- | --- |
| | Hard |
| | Abrasion-resistant |
| | Good compressive strength |
| | Rot-resistant |
| | Low moisture absorption |
| Key features compared to plastic | Strength |
| | Stiffness |
| | Heat |
| | Impact-resistant |
| | Reduces cycle time for injection molding; cools down faster |
| | Less shrinkage on the final product, therefore high tolerances |
| More | www.wtl-int.com |
| | www.hackwellgroup.co.uk |
| Typical applications | A large market is in window frames and decking. Other products include sheet panels, pipes, tubes, buckets, fittings, and bowls. |

# Wood + plastic

more: Extrusion 030, 058, 073, 088, 090, 102, 108, 114, 120 Injection molding 016, 020, 021, 030, 043, 051, 052, 054, 058, 073, 090, 097, 100, 114 Polyethylene 023, 029, 046, 052, 097, 110, 119 Polypropylene 017, 018, 036, 043, 045, 073, 088, 119, 125 Polystyrene 038, 040, 042, 047, 078 Rotational molding 110, 114

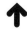

094

A range of recycled plastic materials made from a variety of products including cellphones, Wellington boots, dolls, CDs, and water bottles

# All that jazz

| Dimensions | Sheet sizes from 1200mm x 800mm to 3000mm x 1500mm. Thickness from 2mm–25mm |
|---|---|
| Key features | Made from recycled material |
| | Recognizable and powerful esthetic |
| | Low fabrication costs |
| | Available in arrange of thicknesses |
| More | www.smile-plastics.co.uk |
| Typical applications | The range of materials has been used in guitar bodies, kitchen worktops and doors, chairs, tables, and exterior and interior screens. |

The plastics recycling industry has been going for about 50 years. Initially the motivation to recycle was purely commercial, with companies looking for ways to reuse waste materials. In terms of the end results, the outcome was not that exciting, with the recycled materials being hidden behind bland, gray, almost embarrassed surfaces. By setting up his company Smile Plastics ⟩ , Colin Williamson saw the opportunity to reinterpet the recycling process by making it a highly visible feature of the final material. Based on the "jazz" effect (a pattern that was born out of molders experimenting with leftover virgin plastics during the molding process), Williamson saw the potential of this decorative accident to create a material that wore its recycling badge on its sleeve.

The specks of discarded and shredded products clearly visible in the surface of these sheet materials is reminiscent of compacted cars, or the effect of someone taking a section of a compressed landfill site. The visible history of the discarded products compacted into the surface tells the story of the material and of the times, mentally closing the loop in terms of what happens to the material once it is recycled.

This material makes people far more willing to enter into recycling schemes because they can see the benefit. The esthetic of discarded items, such as detergent bottles, changes as the discarded items change (with recent additions including mobile phones), and these are compressed together into sheets. Depending on the origin of the virgin material the various products can have tactile qualities that range from soft and supple to hard and resilient.

more: Smile Plastics Ltd 089

# 096

# Can the can

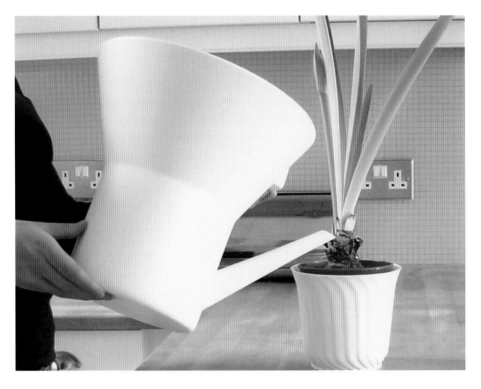

As environmental issues become increasingly mainstream, so too are the related products that are available to consumers. Products and services are emerging that combine esthetic pleasure with a measure of ethical fulfilment.

This project looks at how one of the most banal object typologies could merge with an environmental activity to produce a new hybrid. This watering can-cum-trashcan is based on the observation that a watering can often becomes the place in the home where we store and reuse waste water: black tea and coffee; water from boiling or steaming; water from vases of flowers; rainwater, and so on—all of which is good for our plants.

The project addresses the question of what a product might look like if it was to be both liquid trashcan and watering can. The unique esthetic is driven by its inviting, flared spout, which embraces this new function. As well as acknowledging that there is something good in dirty water, its esthetic reflects designers' growing acceptance that environmental products need not look like they should sit in a shed at the back of the yard.

| Dimensions | 260mm x 275mm x 405mm |
|---|---|
| Key features | Waxy |
| | Easy to mold |
| | Tough at low temperatures |
| | Low cost |
| | Flexible |
| | Good chemical resistance |
| More | hugojamson@hotmail.com |
| | www.rotomolding.org |
| Typical applications | A number of large-scale children's toys are made from HDPE. Other products include: chemical drums, toys, household and kitchenware, cable insulation, carrier bags, automobile fuel tanks, furniture, and the iconic Tupperware. |

Watering can
Designer: Hugo Jamson
Client: Concept project
Date: 2005

# Plastic from corn

Cup and fork made from Naturework® PLA

| Key features | Comes from an annually renewable source |
| --- | --- |
| | Stiffness and processing temperatures similar to polyolefin resins |
| | Compostable |
| | Good clarity |
| | Good surface finish |
| | Low odor |
| More | www.natureworksllc.com |
| Typical applications | Blow-molded bottles; water-based emulsions; clothing; carpet tiles; rigid thermoformed food and beverage containers; diapers; adhesives; and geo textiles. |

"Your food comes from nature; so does your container," proclaims the NatureWorks® website. More and more major plastics producers are having to address environmental issues with regard to their materials. One of the largest sectors for new development is in the area of degradable plastics and plastics from renewable sources.

NatureWorks® PLA is a technology based on the ability to extract the starch from corn and other plants to make polyactide (PLA) polymer. Once the corn has been milled, the starch that is present is separated from the raw material. Unrefined dextrose is produced from this starch. The dextrose is then turned into lactic acid, using a similar process to that for making wine and beer. This dextrose is the same lactic acid that is found in food additives and also in human muscle tissue. Then, through a special condensation process, a cyclic intermediate dimer, also known as lactide, is formed. The lactide, which is the monomer, is purified through vacuum distillation. The process is completed by polymerization, which happens through a solvent-free melt process.

The ultimate aim of the manufacturer of NatureWorks®, Cargill Dow, is to produce PLA more cheaply than PET resin ↘ and eventually become a substitute for polyethylene ↘ . Concentrating on the disposable cutlery and packaging markets, the material helps give integrity to an industry that is lacking in environmental credibility.

The products have all the elements you would expect of a packaging material, with high clarity and hinges. To all intents, it would be indistinguishable from a standard product. However, apart from the injection-molded ↘ products, PLA can be modified to produce a variety of applications such as fibers, foams, emulsions, and chemical intermediaries.

more: Injection molding 016, 020, 021, 030, 043, 051, 052, 054, 058, 073, 090, 093, 100, 114 PET 018, 038, 078, 120, 121 Polyethylene 023, 029, 046, 052, 093, 110, 119

# 099 Production Plastics

# 100

# Big moldings

The world of manufacturing is as complex and vast as the materials that inhabit it. New techniques are being developed all the time to help convert both new and existing materials into new and exciting forms. There are layers of methods split and divided by material families; processes that are specific to industries; and processes within processes. However, at the top of the knowledge tree for designers is injection molding ⅊ , among others. Within it there are various subcategories, one of which is gas-injection molding.

The difference between gas-injection molding and injection molding is that at the stage where molten plastic is injected into the mold, gas is also introduced, with the result that plastic is forced against the walls of the mold until the plastic has cooled. This has several advantages over conventional injection molding. First, products in conventional molding require a solid section of plastic, which is fine for thin wall thicknesses, but for large-scale, thick sections, products become heavy and require a lot of material. Gas injection molding, however, allows for parts to be made with varying wall thicknesses and hollow sections filled with air. The shrinkage and sink marks that are common in injection moldings are eliminated due to the even distribution of pressure within the mold, which also results in greater surface definition.

The Italian manufacturer Magis ⅊ has years of experience in producing plastic design-led products, and it uses gas injection molding on some of its large-scale pieces of furniture. This range of chairs is typical of the process.

| Dimensions | 560mm wide x 820mm high |
|---|---|
| Key features | Uses less material |
| | Reduced cycle times |
| | Allows for components to be made with variable wall thickness |
| | Reduced weight |
| | Cost-effective |
| | Less sink marking |
| | Greater surface definition |
| More | www.gasinjection.com |
| | www.magisdesign.com |
| Typical applications | If you think of the big plastic garden furniture available from garden centers, the chances are they have been made by gas-injection molding. However, virtually all moldable parts can be gas injection molded, including coat hangers, vacuum cleaner bases, and wing-mirror housings. External gas-injection molding is often used for components with large surface areas, such as auto body panels, furniture, and refrigerators. |

Cinecitta: director's chair made from glass-filled polypropylene with seat and back in waterproof nylon
Designer: Enzo Mari
Date: 2003

more: Injection molding 016, 020, 021, 030, 043, 051, 052, 054, 058, 073, 090, 093, 097, 114 Magis 036, 046

# Mass customization

| | |
|---|---|
| Dimensions | **360mm x 280mm x 60mm** |
| Key features | **Allows for rapid response to fashion** |
| | **Can provide enhanced functional surface** |
| | **Cost-effective** |
| | **Enhances branding possibilities** |
| More | **www.inclosia.com** |
| | **www.tulip-ego.com** |
| | **www.mvgdesign.us** |
| Typical applications | **The process can be used on any plastic molded product. However, so far the most popular products have been electronic devices such as mobile phones, PDAs, and computer peripherals.** |

**Tulip E-Go Laptop**
**Designer: Marcel van Galen**
**Client: Tulip Computers**
**Date: The EXO™ overmolding system was launched in early 2003. The E-Go was launched in 2005.**

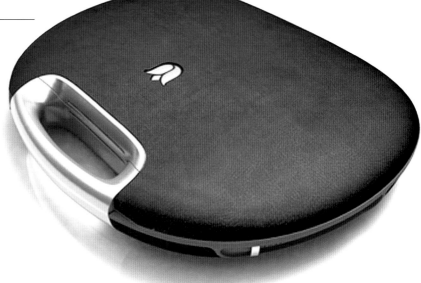

The design community is continually exploring new contexts, scenarios, and new hybrids for technology-led products. The rapid growth of the personal technology area has allowed designers to play with new functions and applications for new typologies. All manner of music, information, organization, and communication products used to be exclusively made from molded standard ABS (acrylonitrile butadiene styrene) ➘ , derived from a global visual identity. But now, with the ability to incorporate softer materials into the sphere of mass production, design has been liberated to create new visual languages for products and can offer regional and personal ranges with the addition of new skins.

US-based company Inclosia Solutions has developed a patented technology, the EXO™ overmolding system, which allows materials such as wood, leather, metals, and fabrics to be incorporated into plastic moldings. The technology enables manufacturers to quickly and cost-effectively change surface designs and apply functional and esthetic decoration to a range of products.

Based on a multistage process where the skin is inserted into the mold and plastic injected over it, the technology uses a full range of sheet materials to create esthetic and functional qualities with a high-volume, mass-market product. Inclosia opens the door for technology to be dressed in soft, tactile, and scented woods and leathers, or the cold, hard surface of aluminum ➘ .

more: ABS 021, 036, 041, 047, 070, 078, 115 Aluminum 017, 042, 043, 051, 074, 079, 080, 108, 121

# 102 Personal mass production

Provista® is a brand of PETG (polyethylene terephthalate glycol) ↘ copolyester from Eastman Chemicals ↘ . It was developed for use in extrusions ↘ that required optical clarity, toughness, and flexibility. All these properties are evident in Tom Dixon's ↘ "Fresh Fat" range of products.

Beyond the choice of plastic material, what makes this project especially interesting is the combination of a high-volume, mass-production process, and the interpretation of plastic as a handmade craft project. There are many examples of designers using plastic in a craft-like process, but here Tom Dixon uses a high-volume machine as his tool. This unorthodox approach contradicts preconceived notions of plastic as the material of mass production.

The project provides a new opportunity for combining machine and hand production, in a method that might be closer to making food than plastic, allowing for the personalization of a mass-production process. If there were ever a project that epitomized the visual interpretation of plastic processing, this would rank highly. In its tangled, spaghetti-like form, it expresses the simple reason why plastic is so good at the job of forming shapes. When heated, this pliable, gooey material takes on whatever shape contains it and it stays that way when it cools.

| Dimensions | 430mm x 900mm x 560mm |
|---|---|
| Key features | Gleaming transparency and clarity |
| | High-gloss surface |
| | Does not stress-whiten |
| | Toughness with flexibility |
| | Ease of processing and fabrication |
| | Excellent chemical resistance |
| | Environmental advantages: has no plasticizers or halogen-containing compounds, and when burned produces no toxic substances |
| | FDA compliance for food-contact applications |
| More | www.eastman.com |
| | www.tomdixon.net |
| Typical applications | Provista® was developed specifically for extruding into profiles where high clarity and finish were important. Its applications include food packaging, furniture, and point of sale. |

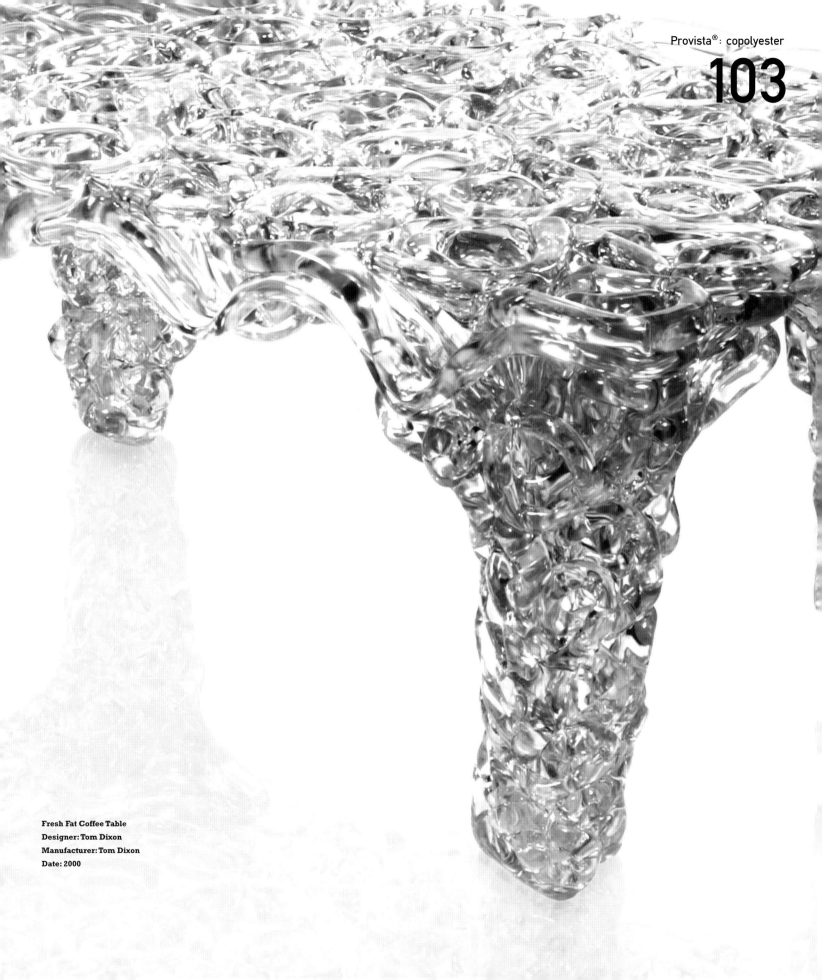

Fresh Fat Coffee Table
Designer: Tom Dixon
Manufacturer: Tom Dixon
Date: 2000

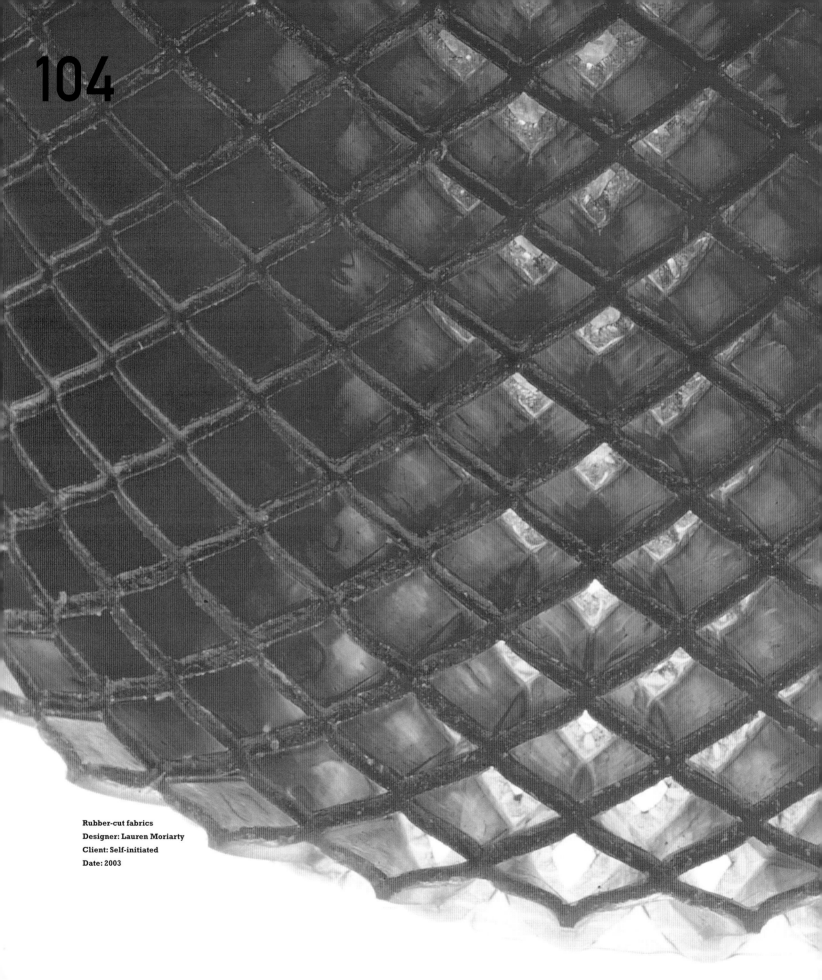

104

Rubber-cut fabrics
Designer: Lauren Moriarty
Client: Self-initiated
Date: 2003

# 3D fabrics

With an emphasis on the constant development of new ways to work with materials, designer Lauren Moriarty has mixed contemporary textiles with product design to create a fresh and original approach. Combining a foam material and laser cutting, Lauren has built a range of patterns that explores the use of rubber and plastics to create a modern take on traditional textile techniques.

She says: "Many of the pieces I produce are laser-cut before being molded into shape. The advantage of laser-cutting is the very intricate detail that can be achieved. The cut layers are constructed into three-dimensional pieces and take the form of lighting, cushions, and interior cubes. These three-dimensional 'fabrics' are squashable and have great tactile appeal. The single-layer fabrics relate to the patterns found in lace and constructed textiles, and address the aim of finding new ways to explore textile design using materials not often associated with the subject."

Lauren's approach to experimentation and the resulting flexible, soft, semi-organic, open-cell foam structures and flat patterns define a new application for foams.

| Dimensions | 2mm thick x 500mm width x 1000mm length |
| --- | --- |
| Key features | Lightweight |
| | Flexible |
| | Can be produced in a range of materials |
| | Cushioning |
| More | www.laurenmoriarty.co.uk |
| Typical applications | Cushions, lighting, interior paneling. |

# 106

# Reinventing jewelry

This project is a wonderful combination of material and production, and a great example of a cross−referencing of products. Combining high- and low-value objects, the Postcardring© brings a new meaning to the whole concept of value.

Designer Barbara Schmidt defines her collection of patented, wearable plastic postcards as "spontaneous happiness, colorful sensibility, and playful lightness combined with the joy of giving and decorating oneself. This is the spectrum of positive emotions appealed by the newly developed ring postcard."

The rings can be sent in an envelope and brought to life by popping out the ring from its die-cut postcard and hooking the ends together to wrap it around the finger. The project encompasses a range of sheet materials and colors from which the rings can be ordered. Apart from them being a completely new expression of jewelry, the products make a clever connection between low-tech die-cutting ↘ technology and do-it-yourself assembly.

Postcardring©
Designer: Barbara Schmidt
Manufacturer: Barbara Schmidt

| Dimensions | 230mm x 120mm |
|---|---|
| Key features | Can be heat-welded, ultrasonically welded, riveted, stitched, and embossed |
| | Easy and versatile processing |
| | Excellent resistance to chemicals |
| | Excellent live hinge potential |
| | Low water absorption and permeability to water vapor |
| | Recyclable |
| | Very cheap tooling |
| | Manual assembly process |
| | High print adhesion |
| | Virtually impossible to tear |
| | Low density |
| More | www.barbara-schmidt-schmuck.de |
| Typical applications | Die-cut polypropylene is huge business; it is used in everything from high- and low-end packaging, stationery, table mats, and folio cases, to the more design-led applications of furniture and lighting. |

more: Die cutting 125

| Dimensions | 730mm x 440mm x 440mm |
|---|---|
| Key features | Virtually limitless possibilities of shapes |
| | Available in a range of materials |
| | Low capital investment |
| More | www.patrickjouin.com |
| | www.materialise.com |
| Typical applications | Car manufacturers, engineers, designers, and architects use stereo lithography to produce prototypes and concept models. In manufacturing it is used to create patterns and masters for melds and short run final products. Recently, surgeons have also begun to use this technology to recreate affected anatomy in preparation for complicated operations. |

# Objects to go

Rapid prototyping is changing the world of production, as it allows for previously impossible forms to be produced as multiples. The term rapid prototyping is somewhat outdated. Originally, it was a process used to develop samples quickly, but it is now being pushed outside of this role into a much broader way of making objects. The tool provides freedom from the constraints of the manufacturing process to offer a new world of possible objects.

In the last ten years, there have been a number of projects exploring the various forms that this exciting technology takes. There is an ever-increasing number of methods within this manufacturing family. Most common types use lasers and photosensitive resin for stereolithography—laminated paper built up in layers and ink-jet. This project uses a range of powder and liquid polymers to create the various pieces from inputted designs.

In a process that is so forward-looking, there is nevertheless a reference to the past in the sense that objects are created from solid materials in a one-off. As someone who is excited by the production of objects, I think this has to be one of the most intriguing areas to watch, where complex structures are slowly brought to life from a solid mass over a period of a hours. Objects reveal themselves like magic.

Rapid prototyping may have the same sort of impact that 3D modeling on the computer had in terms of changing the form of products. It will be interesting to see how the speed at which 3D experiments can be made will change the look of products.

**Solid chair**
**Designer: Patrick Jouin**
**Manufacturer: 3D Systems**
**Date: 2004**

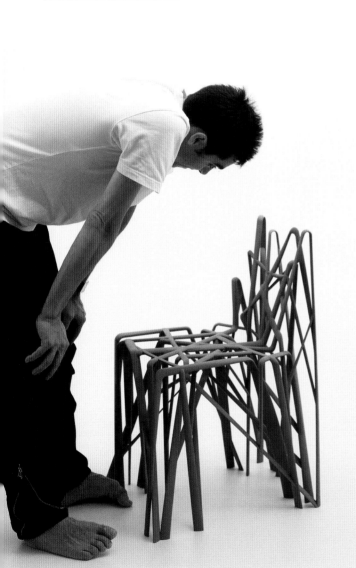

# The pull of the new

In principle, pultrusions are similar to extrusions ↘ , but instead of pushing doughy plastic through a die, the plastic is pulled, taking with it fibers to act as reinforcement. It is here that the similarity ends. Whereas extrusions are used for low-temp metals and plastics to form a continuous length of the same shape, pultrusions make the same type of shape, but instead create high-strength and highly rigid profiles.

Pultrusions provide another example of plastics competing with metals. The resultant forms offer super rigidity, with an 80–75 percent weight reduction on steel ↘ and 30 percent on aluminum ↘ , as well as a greater dimensional stability than these metals.

Increasing the physical properties for both engineering and design applications, pultruded plastics offer the toughness of metals with the advantages of low weight and corrosion resistance. They are extremely dense and hard: they feel more like metal than plastic and "clank" like a piece of metal when you knock them. They can also be colored without the problem of chipping. Surface decoration can be applied to mimic grain and other textures. As you would expect from plastics, pultruded plastics are also non-conductive, which makes them an ideal material for electricians' ladders.

| Dimensions | Profiles range from 1mm–250mm diameter |
|---|---|
| Key features | Highly rigid |
| | Colorable |
| | Strong |
| | Lightweight |
| | Non-conductive |
| | Corrosion-resistant |
| | Good dimensional stability |
| More | www.pultruders.com |
| | www.acmanet.org |
| | www.fibreforce.co.uk |
| Typical applications | As an alternative to metal, pultrusions are used for permanent and temporary structural components for industrial plants; vandal-resistant indoor and outdoor public furniture; funfairs, and exhibition stands. Smaller-scale applications include electrically insulated ladders; ski poles; racquet handles; fishing rods; and bicycle frames. Perhaps more surprisingly, pultrusions have a similar resonance to certain woods, which has led to them replacing hard wood frames in xylophones. |

If you find a forgotten product typology that is mundane and everyday in its use and redesign it to give it a distinctive visual personality, you are halfway to creating a unique and recognizable product. If design has now fully explored every part of the product world for human beings, then it is now engaging with the animal kingdom and applying contemporary esthetics to cats, dogs, and chickens.

The Eglu chicken coop, made by British company Omlet, is made from rotational-molded polyethylene ⩘ . This material is similar to PVC ⩘ in the volume of its consumption worldwide and its availability in an extensive range of varieties. Some formulas of polyethylene are bendable and supple, while others are rigid; some are highly resistant to breaking, whereas others are easily broken. However, as a family, polyethylenes are characterized by chemical resistance and toughness. High-density polyethylene (HDPE) ⩘ is used in the Eglu because of its stiffness and strength.

Apart from being one of a kind and providing a giant leap in chicken architecture, the Eglu is a wonderful advert for rotational molding ⩘ in polyethylene. The bright, contemporary colors and large moldings are the perfect opportunity to show one of the key advantages of this prolific partnership of material and molding technique.

**Eglu chicken coop**
**Designers: James Tuthill, Johannes Paul, Simon Nichols, and William Windham**
**Manufacturer: Omlet**
**Date: 2004**

| Dimensions | 700mm x 800mm x 800mm |
|---|---|
| Key features | Waxy |
| | Easy to mold |
| | Tough at low temperatures |
| | Low cost |
| | Flexible |
| | Good chemical resistance |
| More | www.omlet.co.uk |
| Typical applications | A number of large-scale children's toys are made from HDPE. Other products include chemical drums, toys, household and kitchenware, cable insulation, carrier bags, car fuel tanks, furniture, and Tupperware. |

# Chicken architecture

# 113 Objects

# 114

Bic® products inhabit the world of everyday classics, where design and utility form seamlessly. Behind these icons of production and design lies the selection of materials that ensures that each of the four million Bic® lighters that are bought every day perform their intended task.

# Light work

The biggest piece of material on the Bic® lighter is the acetal ↘ handle. With its use of bright color, it proclaims its use of plastic in an archetype of disposability. This is an engineering material used not for its esthetics but for its functionality. It can be injection-molded ↘, extruded ↘, blow-molded ↘, rotational-molded ↘, stamped, and machined. Comparable to polyester ↘, PTFE ↘, and nylons ↘, acetals have some advantages over nylons at lower temperatures and are stiffer with better fatigue resistance. They also have a natural lubricant, especially in environments with a high moisture content.

Using DuPont's ↘ Delrin® ↘, the Bic® lighter exploits this brand of acetal resin's high tensile strength, its ability to be knocked around, and its ability to withstand chemicals, including gasoline.

| Dimensions | 60mm high |
| --- | --- |
| Key features | Excellent impact strength |
| | Excellent abrasion resistance |
| | Low friction |
| | Excellent dimensional stability at a range of temperatures |
| | High stiffness |
| | Toughness at low temperatures (down to – 40°C) |
| | Excellent resistance to chemicals |
| | Excellent dimensional stability |
| | Resilient |
| | Good electrical-insulating characteristics |
| | Excellent fatigue resistance |
| More | http://plastics.dupont.com |
| | www.bicworld.com |
| | www.dupont.com/enggpolymers/europe/ |
| | www.basf.com |
| Typical applications | This material can be used in diverse applications, from the base plate of a ski to more banal applications, such as the plastic buckles on rucksacks, where its high strength and moderate flexibility allow for its use as a clip. It is also used for plastic zips, golf tees, gears, and curtain runners. It can be used for mechanical components in food-packaging dispensers, washing machine handles, locking systems for removable frames in inline skates, gears in water sprinklers, and in replacing metals in window and door furniture, locks, handles, and latches. Its resistance to chemicals also makes it a good choice for perfume bottles. |

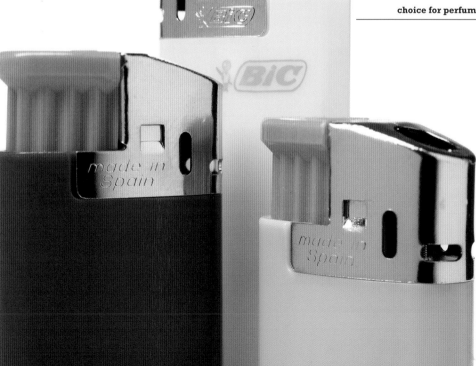

Bic® Mini Tronic
disposable lighter
Steel and Delrin® plastic
Date: 1973
Manufacturer: Bic

more: Acetal 021, 078 Blow molding 016, 046 Delrin 021 DuPont 023, 029, 030, 068, 071, 073, 076 Extrusion 030, 058, 073, 088, 090, 093, 102, 108, 120 Injection molding 016, 020, 021, 030, 043, 051, 052, 054, 058, 073, 090, 093, 097, 100 Nylon 030, 066, 068, 071, 074, 122, 124 Polyester 120, 121 PTFE 030–031 Rotational molding 093, 110

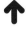

There is one good reason why Lego® is made from ABS (acrylonitrile butadiene styrene) ↘ . Apart from the fact that it has a high-gloss surface, and is cost-effective and easy to mold, it is also one of the toughest commodity plastics on the market. Have you ever known Lego® to break?

Lego® is one of the world's favorite toys. The name dates back to 1934. It is a combination of the Danish words "leg" and "godt," which translates into English as "play well" and into Latin as "I put together." It is a product that has embraced plastic and has used advances in the material to evolve the brand into a series of products that keep up to date with children's imaginations and trends in toys.

On average, for every person on Earth there are fifty-two Lego® bricks. This proliferation has made it an icon of plastic. The bricks require an extremely high degree of manufacturing tolerances—0.002mm—for the "stud-and-tube" principle to work. That process keeps the 400,000,000 children and adults who play with Lego® bricks every year happy, and makes sure that they always, always stick together.

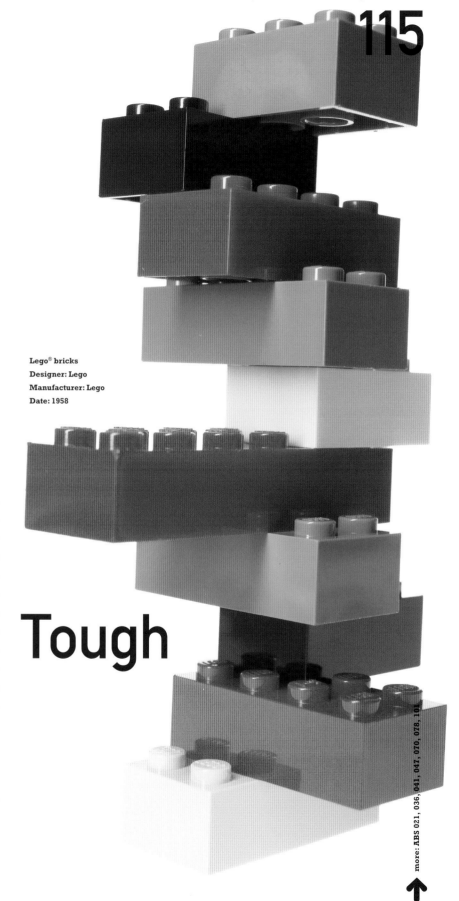

Lego® bricks
Designer: Lego
Manufacturer: Lego
Date: 1958

Tough

| Key features | High-impact strength, even at low temperatures |
| --- | --- |
| | Low cost |
| | Versatile production |
| | Good resistance to chemicals |
| | Good dimensional stability |
| | Scratch-resistant |
| | Flame-resistant |
| | Can achieve a high gloss |
| | Excellent mechanical strength and stiffness |
| More | www.lego.com |
| | www.geplastics.com |
| | www.basf.com |
| Typical applications | A huge range, from cellphone casings, where it is combined with PC to make even tougher moldings, to shower trays and food processors. ABS is also used in a whole range of white goods and automotive consoles. |

more: ABS 021, 036, 041, 047, 070, 078, 108

# Environmental PVC

Polyvinyl chloride (PVC) ↘ was one of the first widely available plastics, and it still occupies one of the largest areas of plastics consumed worldwide. It is probably the plastic that, along with polythene, has most filtered into common language. However, since the 1980s, PVC has developed a reputation as being an environmentally unfriendly material. These concerns come from several fronts. The first is the use of a chlorine compound that forms such a large part of PVC's composition. Unlike many other plastics, PVC is based on the use of approximately 50 percent petrochemicals; the other half is made of a chlorine-based compound. This marks one of its key advantages to producers, as the price of PVC is not as heavily based on price fluctuations of oil. However, the downside is that the production of PVC produces harmful dioxins.

The second main environmental issue is based on the use of the stabilizers and plasticizers in the production of the material. Stabilizers are used to impede degradation and plasticizers to increase flexibility. Both of these additives have problems. Stabilizers use heavy metals such as lead and barium, and plasticizers containing hormone disrupters.

There are moves to reduce these various problems by the manufacturers: they can reduce the amount of dioxins being produced and can use organic stabilizers. The PVC industry's defense lies in what they claim is the low level of risk and likely exposure to these substances, and the fact that PVC has been used in the medical industry for many years for blood bags, where the use of plasticizers has been shown to extend the shelf life of blood.

Designed by Karim Rashid ↘ and using an environmentally friendly form of PVC, this dog toy is the lifestyle alternative to a wooden stick. It expresses the idea that a product for a pet can also be something that the owner would enjoy possessing. This product (unlike most pet products, which look as if they were bought at a craft fair) has a fantastic shape that you would not mind having lying around at home.

more: Karim Rashid 041, 044–045 PVC 038, 066, 110, 126–127

| Dimensions | 200mm x 200mm x 35mm |
| --- | --- |
| Key features | Easy to form |
| | Cheap |
| | Easy to color |
| | Water- and chemical-resistant |
| | Available in a variety of forms |
| More | www.ecvm.org |
| | www.karimrashid.com |
| | www.forthedogs.com |
| Typical applications | It is difficult to summarize the versatility of this material and the markets it is used in. Applications include dip-molded bicycle handles, drain pipes, flooring, cabling, artificial skin in emergency burns treatment, sun visors, domestic appliances, raincoats, credit cards, and inflatable toys. Unplasticized or rigid PVC (PVC-U) is used extensively in building applications such as window frames. |

Dog Bone
Designer: Karim Rashid
Manufacturer: For the Dogs

# Material tailoring

The design of these cup and snack containers
uses an interesting combination of materials,
brought together to withstand the innocent
brutality of a child's play and the practicalities
of the parents' needs. Designer Chris Von Dolen
explains the rationale behind the choice
of materials...

More     **www.fitch.com**

**www.gerber.com**

**www.exceedmpe.com**

**www.cpchem.com**

**www.glscorp.com**

**www.gesilicones.com**

**Sippy Snacker**
**Designers: Chris von Dohlen,**
**Hugo Eccles, Josh Dickman, Jeff**
**Servaites, and Eric Listenberger**
**Manufacturer: Gerber**
**Date: 2005**

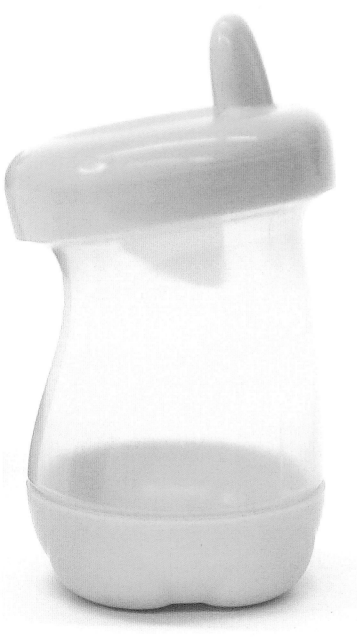

## Lids: polyethylene

"Since the cup is made from polypropylene ↘ , another material is needed to reduce the friction that occurs when moving parts are made from the same material. Also, the lid needed to be durable enough to withstand throwing, biting, and other naughty behavior. Polyethylene ↘ fits the bill nicely, as well as being a stable and safe material used extensively in food and medical applications."

## Cup and snack containers: clarified polypropylene

"Milk doesn't taste very good when you think you're supposed to be getting orange juice! Therefore, the cup needs to be transparent so both child and parent can see what type of drink is inside. Polypropylene seemed like a good option for this product. It is an inert material and is commonly used in the medical industry as well as being a safe material for children. Polypropylene is very durable, and can withstand even the most energetic toddler's day. Although not naturally clear, clarifying agents are added to make it see-through. As far as cleaning, the material can withstand the rigor of dishwashing machines. The overall shape of the vessel was designed to be developmentally appropriate for the novice drinker. Polypropylene's flexibility in choosing manufacturing processes was also essential in maintaining the intended shape. Last but not least, polypropylene's cost fits right in line with the market price for Sippy cups."

## Base: 50:50 mix of polypropylene and TPE

The main issues for the base were: 1) flexibility for snapping onto the bottom of the cup; 2) tackiness to keep the cup from sliding on table tops; and 3) color matching to the lid. As a result, a TPE ↘ was mixed into the polyethylene used in the lid, combining to make a flexible, mildly tacky, and color-matched plastic.

more:Polyethylene 023, 029, 046, 052, 093, 097, 110 Polypropylene 017, 018, 036, 043, 045, 073, 088, 093, 125 TPE 076–077

Clear and tough polyethylene terephthalate (PET) ⊾ is one of the standard materials for drinks containers. Part of the polyester ⊾ family, which also includes PBT ⊾ and PETG ⊾, it is a crystal-clear plastic that is impervious to water and CO2, which makes it ideal for this application. For bottles, it is often extruded ⊾ with other materials to form sandwiches to increase its properties.

PET is common in drinks and food packaging: carbonated soft drinks have been sold in PET containers for the past twenty years. However, due to beer being more oxygen- and carbon dioxide-sensitive, PET is not generally suitable for beer cans. Miller Brewing Company changed this with the launch of its first plastic beer bottle, using PET, for St Patrick's Day in 2000.

| Key features | Excellent resistance to chemicals |
| --- | --- |
| | Excellent dimensional stability |
| | Tough and durable |
| | Excellent surface finish |
| | Good impact strength |
| | Color can be added for functional use, which provides excellent potential to extend the life of the product |
| More | www.ivv.fraunhofer.de |
| | www.socplas.org |
| Typical applications | Apart from food, drinks, household cleaning products, and cosmetic packaging, other applications for PET include display and decorative film, credit cards, clothing, and auto body panels. |

# Bottling inspiration

Miller claims that the bottle keeps beer cooler longer than aluminum ⊾ cans and as long as glass bottles. The bottle can be resealed and is unbreakable. Altogether, there are five layers in each bottle: sandwiched in between three layers of PET are two layers of oxygen scavengers that stop oxygen getting in or out.

This active and intelligent packaging also uses color in a purely functional application. The technology was developed by Germany's Fraunhofer Institute. Using nature as their inspiration, scientists have developed a plastic film and resin that acts as a UV light blocker. Using natural dyes from chlorophyll, the scientists have come up with a polymer with a hazy green translucency. This is impermeable to UV light, but still lets you see

Recycled PET ⊾ has many uses, and there is a well-established market for this useful resin. By far the largest usage is in textiles. Carpet companies often use 100 percent recycled resin to manufacture polyester ⊾ carpets in a variety of colors and textures. PET is also spun like cotton candy to make fiber filling for pillows, quilts, and jackets. PET can be rolled into clear sheets or ribbon for VCR and audio cassettes.

There is also a certain fascination with the drinks bottles made from PET, which means that people are always trying to find new uses for them. The bottles can be used to produce anything from bottle boats in Indonesia to water bottle rockets and bird baths. Empty bottles can be filled with cement and used as building bricks. In terms of the material, PETs represent one of the biggest areas of recycling, with the bottles being ground down to make carpets, fibers, and the filler for pillows and clothes: five two-liter PET bottles can yield enough fiber to make a ski jacket.

# Reusable

| | |
|---|---|
| Key features | **Recyclable (PET is one of the most recycled plastic resins)** |
| | **(Other benefits as featured opposite.)** |
| More | **www.eastman.com/Brands/Vitiva** |
| Typical applications | **Recycled PET has any number of uses within the packaging industry, but can also be spun to produce a range of fillings for furnishings, or rolled into sheets and ribbons.** |

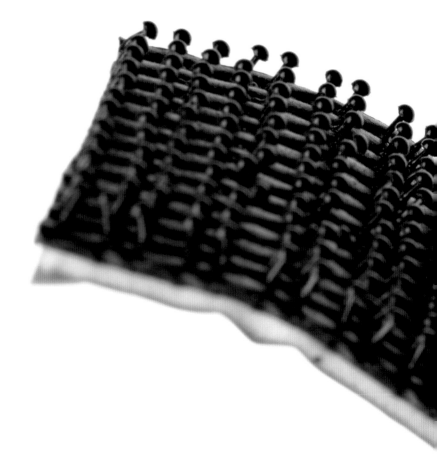

Is it a tape, is it a fabric, or is it a plastic molding? Whatever category it fits into, Hook and Loop (more commonly know as Velcro® ↘) is a product that offers a great case study for a use of plastic. It is also one of the most useful inventions of the twentieth century.

It is well known that the structure of Velcro® fibers is based on a mechanical fixing that is borrowed from nature, where the tiny hooks—commonly known as burrs—found on the end of some seed pods attach the seed more easily to an implantable surface that might brush past. It was this observation that led to Velcro®'s name being patented in the early 1950s by Swiss engineer George de Mestral: the name derives from the French words for velvet (velour), and hook (crochet).

Velcro® is another example of a trademark name, like nylon ↘ and Teflon ↘ , that has passed into common language. This product has been used in both everyday contexts and advanced applications, allowing us to create new functions and products. It is another product that demonstrates the flexibility of plastics, and is unique in that it crosses the boundary between fabric, tape, and molded plastic. It also provides a case study because it appeals on so many levels: it combines the beauty of a simple observation into a product that has filtered into every possible area of application.

There are variations on standard Velcro® available, including conductive Velcro® and a superstrong product branded under the name Dual Lock™. Instead of the hook-and-loop principle, this relies on a series of tiny mushrooms to join the two identical halves of the material together. In all versions of the material, this is a product that has brought new potential to the use of pliable plastics to be used as fixings.

# Peelable fastener

| Key features | Strong |
| --- | --- |
| | Lightweight |
| | Durable |
| | Washable |
| | Available in a range of grades |
| More | www.velcro.com |
| | www.3m.com |
| Typical applications | Plastics have allowed for a mass of new types of fixing mechanisms that exploit the flexibility and resilience of plastics. Velcro® has an incalculable number of applications in which it is used, ranging from wearable to industrial. 3M, the makers of Dual Lock™, claim that its product has five times the tensile strength of standard Velcro®. It is used to invisibly attach doors and panels, headliners to cars, and in other applications that require superior strength. |

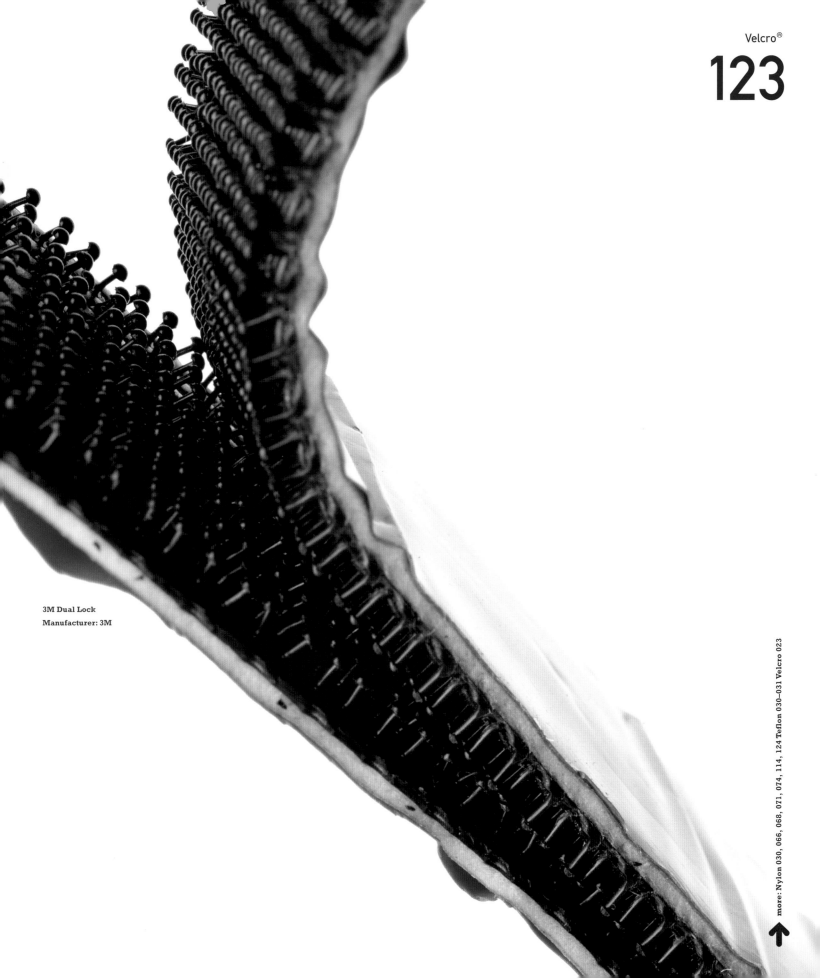

3M Dual Lock
Manufacturer: 3M

↑ more: Nylon 030, 066, 068, 071, 074, 114, 124 Teflon 030–031 Velcro 023

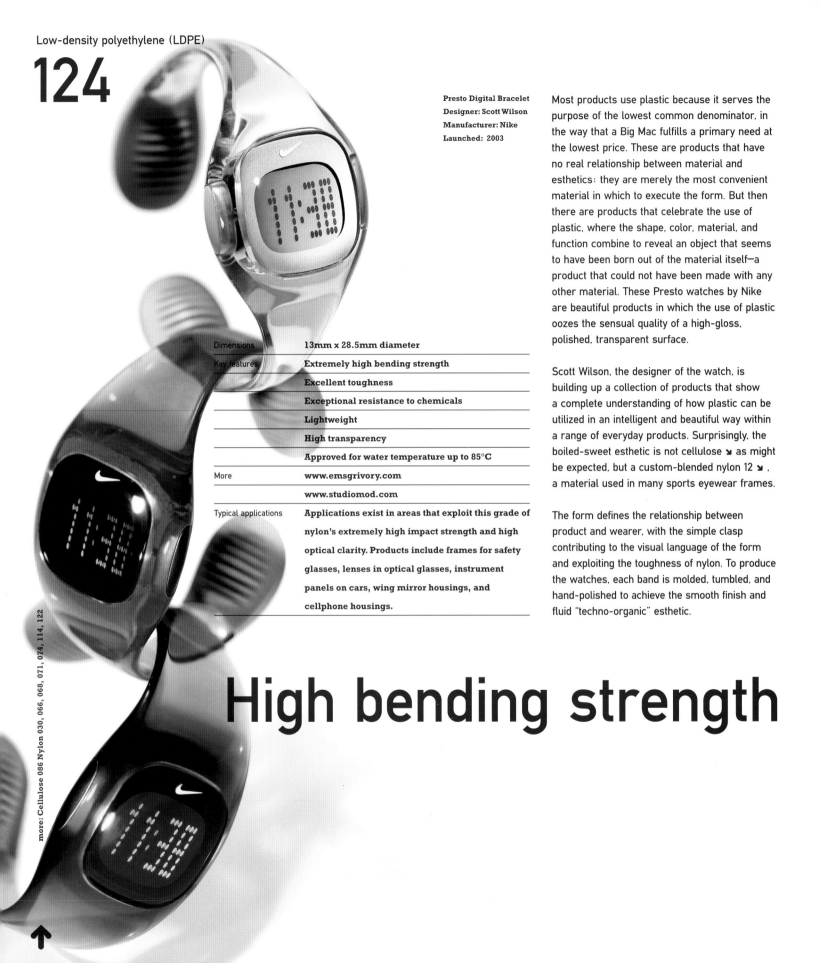

**Presto Digital Bracelet**
**Designer: Scott Wilson**
**Manufacturer: Nike**
**Launched: 2003**

Most products use plastic because it serves the purpose of the lowest common denominator, in the way that a Big Mac fulfills a primary need at the lowest price. These are products that have no real relationship between material and esthetics: they are merely the most convenient material in which to execute the form. But then there are products that celebrate the use of plastic, where the shape, color, material, and function combine to reveal an object that seems to have been born out of the material itself—a product that could not have been made with any other material. These Presto watches by Nike are beautiful products in which the use of plastic oozes the sensual quality of a high-gloss, polished, transparent surface.

Scott Wilson, the designer of the watch, is building up a collection of products that show a complete understanding of how plastic can be utilized in an intelligent and beautiful way within a range of everyday products. Surprisingly, the boiled-sweet esthetic is not cellulose ⊾ as might be expected, but a custom-blended nylon 12 ⊾ , a material used in many sports eyewear frames.

The form defines the relationship between product and wearer, with the simple clasp contributing to the visual language of the form and exploiting the toughness of nylon. To produce the watches, each band is molded, tumbled, and hand-polished to achieve the smooth finish and fluid "techno-organic" esthetic.

| | |
|---|---|
| Dimensions | **13mm x 28.5mm diameter** |
| Key features | **Extremely high bending strength** |
| | **Excellent toughness** |
| | **Exceptional resistance to chemicals** |
| | **Lightweight** |
| | **High transparency** |
| | **Approved for water temperature up to 85°C** |
| More | **www.emsgrivory.com** |
| | **www.studiomod.com** |
| Typical applications | **Applications exist in areas that exploit this grade of nylon's extremely high impact strength and high optical clarity. Products include frames for safety glasses, lenses in optical glasses, instrument panels on cars, wing mirror housings, and cellphone housings.** |

# High bending strength

the surprising
## FOLD HANGER

# Molded origami

Polypropylene (PP) ↘ has been a relatively new introduction to plastics. Originally developed in the 1950s, this commodity plastic occupies one of the largest segments in the plastic industry.

Polypropylene is as common in its molded form as it is in its die-cut ↘ sheet form, where it offers the designer a halfway point between folded paper and a fully tooled-up, molded product. Like a piece of clever origami, this fold-up coat hanger bridges these areas. As a raw material, polypropylene is relatively cheap and easy to process. It is also one of the best materials for creating live hinges, which is the prominent feature in this little gadget.

The product is one of those small discoveries that you come across that offer little in the way of real value, but provide a small narrative on top of a great case study of the performance of certain plastics. So why put it in a book? Well, because it captures within its creases and hinges a quality that I think is unique to plastic. It is a tactile, playful, and almost disposable example of the banal nature of how plastic can do so many things that we often don't know what to do with. It is part of the world of plastic gadgets, with a combination of origami and surprise that transforms the product from a small rectangle 120 mm x 80 mm into a rigid coat hanger for the executive nomad.

| Dimensions | Expands from 120 mm x 80 mm |
|---|---|
| Key features | Can be flexed thousands of times without breaking |
| | High heat resistance |
| | Excellent resistance to chemicals |
| | Low water absorption and permeability to water vapor |
| | Good balance between toughness, stiffness, and hardness |
| | Easy and versatile processing |
| | Relatively low cost |
| | Low density |
| | Low coefficient of friction |
| More | www.basf.com |
| Typical applications | Garden furniture, food packaging, general household goods, dispensing lids for bathroom shower products, toothpaste tube lids, most products with an in-built hinge, bottle crates, and tool handles. |

more: Die cutting 106 Polypropylene 017, 018, 036, 043, 045, 073, 088, 093, 119

# 126

# Thin and limp

PVC (polyvinyl chloride) ⟍ is a commodity plastic that occupies one of the largest areas of plastics consumed worldwide. It is a material with many personalities, as it can be treated as thermoplastic ⟍ , elastomer, and thermoset plastics ⟍ . In its highly stiff and rigid form, it is known as the poor man's engineering plastic, but it can also be as flexible and limp as a piece of leather. Perhaps it was this analogy that prompted the use of PVC in this shoe by US-based designer Yves Béhar.

The Learning Shoe, which was commissioned by the San Francisco Museum of Modern Art, explores the relationship between a wearable garment and a computer chip. Data is collected about the wearer's feet and walking style, and a smart sole adapts the shoe based on this information. Like a high-tech slipper from the next century, the form is like a seamless extension of the foot that wraps itself around the body like a piece of leather, while at the same time conforming to the soft, glossy language of plastic.

| | |
|---|---|
| Dimensions | **285.75mm x 114.3mm x 63.5mm** |
| Key features | **Easy to form** |
| | **Cheap** |
| | **Easy to color** |
| | **Water- and chemical-resistant** |
| | **Available in a variety of forms** |
| More | **www.fuseproject.com** |
| Typical applications | **It is difficult to summarize briefly the versatility of this material and the markets it is used in. Some applications include dip-molded bicycle handles, drain pipes, flooring, cabling, artificial skin in emergency burns treatment, sun visors, domestic appliances, raincoats, credit cards, and inflatable toys. Unplasticized or rigid PVC (PVC-U) is used extensively in building applications such as window frames.** |

**Learning Shoe**
**Designer: Yves Béhar**
**Date: 2000**
**Client: San Francisco Museum of Modern Art**

more: PVC 038, 066, 110, 116–117 Thermoplastics 046, 066, 072, 080 Thermoset plastics 017, 046, 066

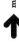

# 129 New Combinations

**Plastic straw and grapevine wire**

**Stretched nylon stocking and resin**

This book is filled with examples of products, furniture, advanced materials and mass-produced, semiformed plastics that you can source, buy, and use. The objective is to inspire new uses for old materials and provoke new applications for emerging materials within a design context. There is, however, another side to plastics that lies somewhere between the handmaking involved in craft objects and the mass production in industrial applications. This is a process of pure experimentation, without any attachment to a product—a place where new surfaces, experiences, functions, and emotions can be created by combining existing materials both randomly and deliberately. This is an experiment born purely out of the curiosity to see what happens when, for example, you combine wax with rubbers, iron fillings with clear resins, or Latex with jelly.

Without preconceptions, and (in contrast to the rest of the book) without references to companies or finished products, these inquiries into material combinations have been put together with a view to discovering new opportunities for allying plastics with other materials. These images are a feast of surfaces, textures, colors, and other sensorial elements, using a large palette of raw ingredients. These experiments have been put together to inspire and suggest new functions, finishes, and tactile experiences for you to digest and enjoy. Their only purpose is to offer inspiration and new recipes for both old and new materials.

Enjoy the feast!

**Fabric and resin**

**Straw, fabric, and card**

Acrylic sheet

Plastic mesh

Latex and silicone

Latex, anti-bacterial fibers, and acrylic

Newspaper and silicone

Expanded foam

Latex, acrylic color, wire mesh, and polypropylene

Metal net and plastic straw

Fabric and resin

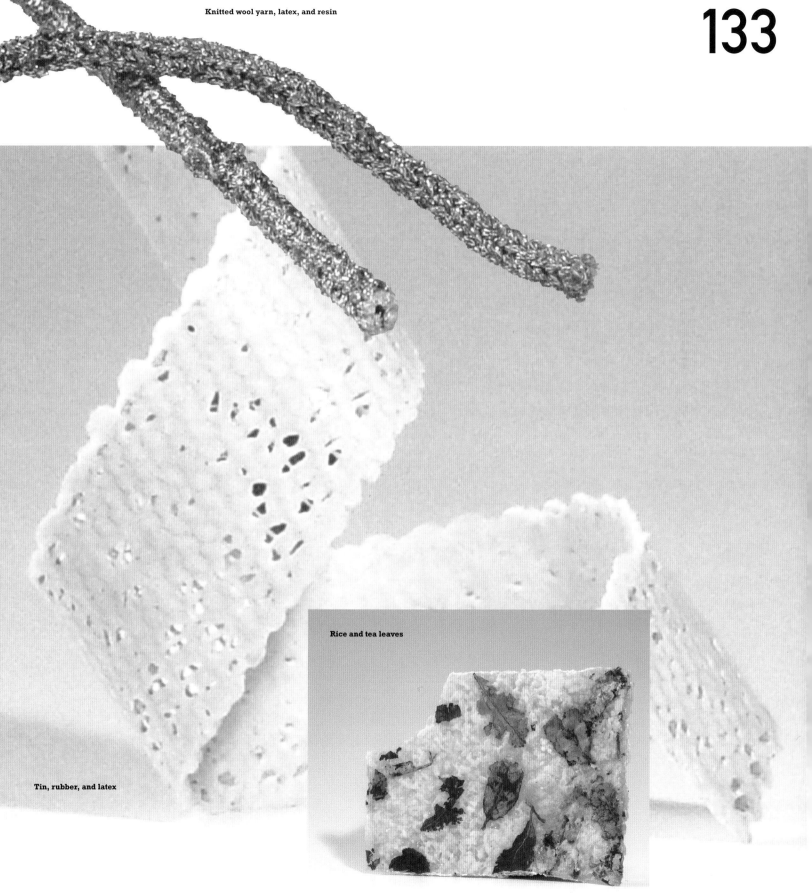

Knitted wool yarn, latex, and resin

Rice and tea leaves

Tin, rubber, and latex

# 135 Appendices

# 136

# Processing plastics

Any discussion about the use of plastics in products cannot ignore the manufacturing techniques that are used to process them. Many plastics can be produced by many of the processes. Choosing the right production process depends on many criteria: the shape of the product, the material requirements, the amount you can invest in tooling, and the number of parts you want to make. Injection molding requires high tooling investment but offers cheap unit costs, whereas rotational molding has lower tooling costs but high unit prices.

Here you will find some of the major processing techniques.

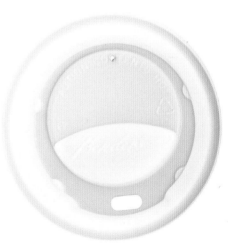

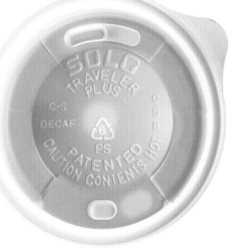

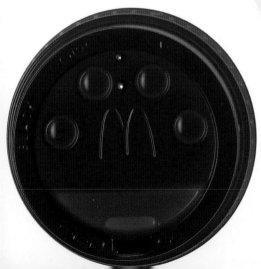

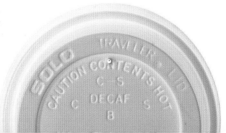

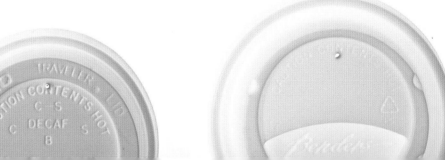

| Blow molding | A production process often featured on children's TV shows when they want to talk about mass production. Images are shown of tubes of plastic blown into a mold which are then sent running around a conveyor belt circuit. This process takes two forms: injection blow molding and extrusion blow molding. |
| --- | --- |
| | Most plastic drink containers use the injection blow molding manufacturing process. The process literally is like blowing a balloon of plastic into a shape, which is determined by the inside shape of the mold. The use of injection molding allows for details such as threads to be formed, which will allow for the fitting of a lid. |
| | In injection blow molding the process involves two stages. First, a tube is injection molded. This will normally include a thread for a lid, which is then rotated to the blow molding tool where hot air is injected into the tube. There it expands to fill the cavity of the final mold. Any textures and surfaces can be formed on the mold cavity and pressed onto the final part. |
| | Extrusion blow molding is a similar process, but instead of the part being injection molded at the beginning, it is extruded as a tube and pinched at both ends and then blown up to fill the mold. |
| Typical Uses | Milk bottles, fizzy drinks bottles, and containers. |

| Calendering | The process of forming thin sheet material from plastic. It is the usual starting point for thermoforming sheets for shower curtains and cling film. Calendering involves plastic pellets being fed through a series of heated rollers to form a sheet or film. Textures can be embossed into the sheet by texturing the rollers. |
| --- | --- |
| Typical Uses | Acetate sheet, PVC sheet, shower curtains, and tablecloths. |

| Extrusion | The best way to understand extrusion is to think of the plasticine toys for children, where you put the plasticine in a tub, turn the handle, and long, continuous lengths of the same shape are produced. This effectively is the same process as that used for modern mass-produced extrusions. |
|---|---|
| | The plastic pellets are poured into a hopper where they are heated and mixed with additives. A screw carries the melted plastic through the shaped die to produce continuous lengths of shapes with the same profile, which are then cooled by air or water. |
| | Extrusion is also used in metal parts, and as with plastic, sheets are cut to their desired length. Window frames, tubes, sheet, and film are all typical examples of the extruding process. Cost compared to injection molding is quite low. However, production is generally limited to minimum-order lengths. |
| Typical Uses | Profiles, pipes, films, paper binders, window frames, Australian dollars, and curtain rails. |

| Compression molding | Compression molding is used primarily for solid parts using thermosetting plastics. Compared with injection molding, extrusion, and other high turn-around production methods, compression molding is slower and more labor-intensive but has the advantage of lower tooling costs. |
|---|---|
| | A measured amount of powdered resin is added to a two-part mold and the action of heat and pressure when the two molds are brought together cures the material. Good surface detail can be achieved with this process, but each piece will usually require some hand finishing. |
| Typical Uses | Melamine plates and toilet seats. |

| Casting | Although with limited use in mass production, casting is one of the easiest and most accessible ways of producing simple solid plastic parts. Most hobby or craft shops will sell the basic molding and casting materials for this process to be completed at home. |
| | Parts are initially made from any material, which can be cast to create a female mold. This mold will then be used to form the final part. Generally, casting materials are acrylic, epoxy, phenolic, polyester, and polyurethane resins. Molds can be created in rigid or soft materials. Resins are usually cured by the addition of a catalyst, and colors, additives, and fillers are added prior to casting. |
| Typical Uses | Paper weights, sheets, and moldings. |

| Rotational molding | Rotational molding is used to create hollow, usually large-scale products. Its relatively low tooling costs make it an ideal process for low production-run pieces. |
| --- | --- |
| | Precise quantities of powder or liquid are loaded into a two-part mold. The amount of material used determines the wall thickness of the final product. The mold is passed through a heating chamber and rotated along two axis. The plastic inside the mold melts, and the rotating motion allows for the plastic to cover the inside mold wall. The tool is cooled and the final product is released. The nature of this process means that the final part will have a uniform wall thickness. Because there is no pressure involved, this process is not ideally suited to parts that require fine detailing. The outside surface will replicate the wall of the mold, while the inside will have an inferior finish. |
| Typical Uses | Storage drums, children's toy vehicles, and wheelie bins. |

| Injection molding | It allows designers virtually total freedom to create almost any imaginable form, and it is found in all areas of plastic product manufacture. Initially limited only to thermoplastics injection molding, it can now also be used for thermosets. |
| --- | --- |
| | The process involves the polymer pellets being fed into the machine through a hopper, and then into a heated barrel. The heat from the barrel turns the plastic into a liquid resin, which is then injected into the mold. Coinjection molding involves the injection of two colors or materials into the same mould to create two distinct finishes or colors. |
| | Injection molding is a high-volume, high tooling-cost process, where parts are produced at a rapid rate. Tolerances and details can be highly controlled. Unit costs are relatively low, but the process generally requires a much higher upfront tooling cost. |
| Typical Uses | Computer housings, Lego, and plastic cutlery. |

| Gas-injection molding | In conventional injection molding thermoplastics are heated and injected into a mold. Channels in the mold act to cool the plastic part before releasing it from the mold. During cooling the part shrinks and moves away from the walls of the mold and, to compensate for this, more material is injected into the mold. |
| --- | --- |
| | An alternative to this widely used method is to inject gas, usually nitrogen, into the mold cavity while the plastic is still in its molten state. This internal force counteracts the shrinkage by inflating the component to force and hold it in contact with the surface of the tool until it solidifies, resulting in parts with hollow sections or cavities. |

| Thermoforming | Thermoforming can be broken down into two main processes: vacuum forming and pressure forming. Both processes use pre-formed plastic sheet as the starting material. The principle of thermoforming relies on the use of either a vacuum or pressure to suck or push the plastic sheet over or into a mold. |
| --- | --- |
| | In vacuum forming a mold is placed on a bed which can be lowered and raised. The plastic sheet is clamped above the mold and heated to the correct temperature, at which point the mold is raised into the soft material and a vacuum is applied. The sheet is then sucked over the mold. |
| | The process of vacuum forming offers cost effectiveness over many other plastic-forming processes in the initial tooling investment. Because of the low pressure that is required, molds can be made from aluminum, wood, or even plaster. The accessibility of this process has meant that it is standard workshop equipment in most art and design workshops, where one-off experiments can be made. |
| | Pressure forming requires a higher pressure than vacuum forming. Instead of a vacuum being used to pull the material over the mold, pressure is used to push it into either a male or female form. Pressure forming is better suited to products that require fine detail in the finishing. |
| Typical Uses | Baths, boat hulls, and take-away lunch boxes. |

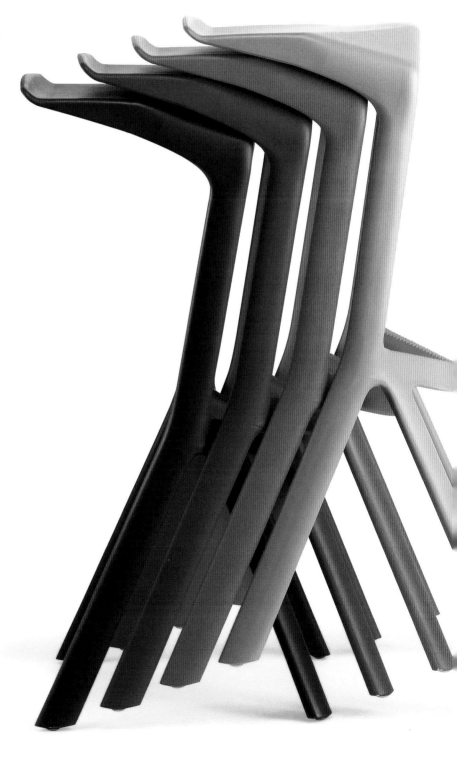

## Injection Blow Molding

screw fills mold

air

## Extrusion Blow Molding

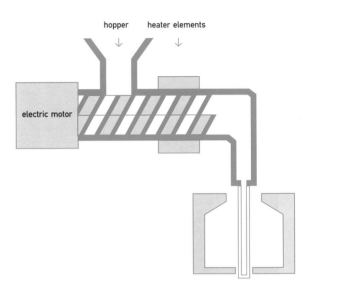

hopper    heater elements

electric motor

## Monomer Casting/Contact Moulding

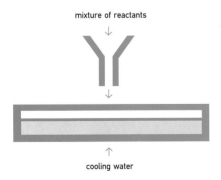

mixture of reactants

cooling water

## Compression Molding

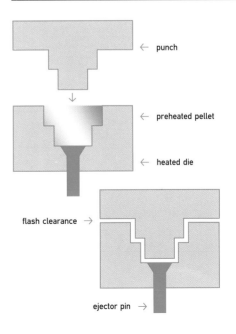

← punch

← preheated pellet

← heated die

flash clearance →

ejector pin →

## Extrusion

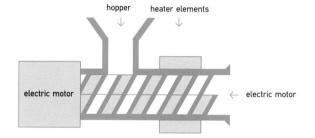

hopper    heater elements

electric motor

← electric motor

## Extrusion of Blow Film

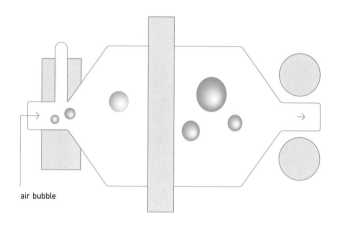

air bubble

## Injection Molding

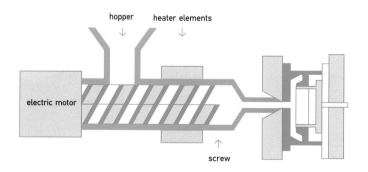

hopper    heater elements

electric motor

screw

## Thermoforming

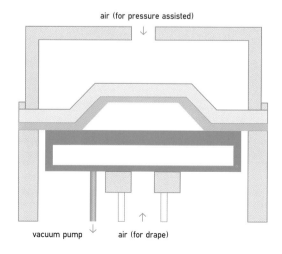

air (for pressure assisted)

vacuum pump    air (for drape)

# Technical Information

| Name | Trade names | Applications | Properties |
|------|-------------|--------------|------------|
| THERMOPLASTICS Acrylics PMMA | Perspex Diakon Oroglas Plexiglas | Signs, inspection windows, tail-light lenses, leaflet dispensers, lighting diffusers, hi-fi dust covers | Hard, rigid, glass-clear, glossy, weather-resistant, excellent for thermoforming, casting, and fabrication |
| Acrylonitrile Butadiene Styrene ABS | Lustran Magnum Novodur Teluran Ronfalin | Telephone handsets, rigid luggage, domestic appliance housings (food mixers), electroplated parts, radiator grilles, handles, computer housings | Rigid, opaque, glossy, tough, good low-temperature properties, good dimensional stability, easy to electroplate, low creep |
| Aramids | Kevlar® | Aerospace components, fiber reinforcement, high-temperature-resistance foams, chemical fibers, and arc welding torches | Rigid, opaque, high strength, exceptional thermal and electrical properties (up to 480°C), resistant to ionising radiation, high cost |
| Cellulosics CA, CAB, CAP, CN | Dexel Tenite | Spectacle frames, toothbrushes, tool handles, transparent wrapping, metallized parts (reflectors etc.), pen barrels | Rigid, transparent, tough (even at low temperatures), low electrostatic pick up, easily molded, and relatively low cost |
| Ethylene Vinyl Acetate EVA | Evatane | Teats, handle grips, flexible tubing, record turntable mats, beer tubing, vacuum cleaner hosing | Flexible (rubbery), transparent, good low-temperature flexibility (-70°C), good chemical resistance, high friction coefficient |
| Fluoroplastics PTFE, FEP | Fluon Hostaflon Teflon | Non-stick coating, gaskets, packings, high- and low-temperature electrical and medical applications, laboratory equipment, pump parts, thread seal tape, bearings | Semi-rigid, translucent, exceptional low friction characteristics, superior chemical resistance, impervious to fungi or bacteria, high-temperature stability (260°C), low-temperature (-160°C), good weathering resistance, and electrical properties |
| Nylons (Polyamides) PA | Rilsan Trogamid T Zytel® Ultramid Akulon | Gear wheels, zips, pressure tubing, synthetic fibers, bearings (particularly for food processing machinery), nuts and bolts, kitchen utensils, electrical connectors, combs, barrier chains | Rigid, translucent, tough, hard-wearing, fatigue and creep resistant, resistant to fuels, oils, fats, and most solvents, can be sterilized by steam |

| Physical Properties | | | Producer | Resistance to Chemicals | | Cost |
|---|---|---|---|---|---|---|
| Tensile modulas | 2.9–3.3 | N/mm² | ICI | Dilute Acid | **** | $$ |
| Notched impact strength | 1.5–3.0 | Kj/m² | ICI | Dilute Alkalis | **** | |
| Linear coefficient of expansion | 60–90 | x 10⁶ | Elf Atochem | Oils and Greases | **** | |
| Max cont use temp | 70–90 | °C | Rohm | Aliphatic Hydrocarbons | ** | |
| Specific gravity | 1.19 | | | Aromatic Hydrocarbons | * | |
| | | | | Halogenated Hydrocarbons | * | |
| | | | | Alcohols | **** | |
| Tensile modulas | 1.8–2.9 | N/mm² | Bayer | Dilute Acid | **** | $ |
| Notched impact strength | 12–30. | Kj/m² | Dow | Dilute Alkalis | **** | |
| Linear coefficient of expansion | 70–90 | x 10⁶ | Bayer | Oils and Greases | **** | |
| Max cont use temp | 80–95 | °C | BASF | Aliphatic Hydrocarbons | ** | |
| Specific gravity | 1.04–1.07 | | DSM | Aromatic Hydrocarbons | * | |
| | | | | Halogenated Hydrocarbons | * | |
| | | | | Alcohols | * | |
| Tensile modulas | n/a | N/mm² | DuPont | Dilute Acid | n/a | $$$ |
| Notched impact strength | n/a | Kj/m² | | Dilute Alkalis | n/a | |
| Linear coefficient of expansion | n/a | x 10⁶ | | Oils and Greases | n/a | |
| Max cont use temp | n/a | °C | | Aliphatic Hydrocarbons | n/a | |
| Specific gravity | n/a | | | Aromatic Hydrocarbons | n/a | |
| | | | | Halogenated Hydrocarbons | n/a | |
| | | | | Alcohols | | |
| Tensile modulas | 0.5–4.0 | N/mm² | Courtaulds | Dilute Acid | ** | $$ |
| Notched impact strength | 2.0–6.0 | Kj/m² | Eastman Chemical | Dilute Alkalis | * | |
| Linear coefficient of expansion | 80–180 | x 10⁶ | | Oils and Greases | **** | |
| Max cont use temp | 45–70 | °C | | Aliphatic Hydrocarbons | **** | |
| Specific gravity | 1.15–1.35 | | | Aromatic Hydrocarbons | * | |
| | | | | Halogenated Hydrocarbons | * | |
| Tensile modulas | 0.05–0.2 | N/mm² | Elf Atochem | Dilute Acid | **** | $ |
| Notched impact strength | no break | Kj/m² | | Dilute Alkalis | **** | |
| Linear coefficient of expansion | 160–200 | x 10⁶ | | Oils and Greases | *** | |
| Max cont use temp | 55–65 | °C | | Aliphatic Hydrocarbons | **** | |
| Specific gravity | 0.926–0.950 | | | Aromatic Hydrocarbons | * | |
| | | | | Halogenated Hydrocarbons | * | |
| | | | | Alcohols | **** | |
| Tensile modulas | 0.35–0.7 | N/mm² | ICI | Dilute Acid | **** | $$$ |
| Notched impact strength | 13–no break | Kj/m² | Ticoma | Dilute Alkalis | **** | |
| Linear coefficient of expansion | 120 | x 10⁶ | DuPont | Oils and Greases | **** | |
| Max cont use temp | 205–250 | °C | | Aliphatic Hydrocarbons | **** | |
| Specific gravity | 2.14–2.19 | | | Aromatic Hydrocarbons | **** | |
| | | | | Halogenated Hydrocarbons | * variable | |
| | | | | Alcohols | **** | |
| Tensile modulas | 2.0–3.4 | N/mm² | Elf Atochem | Dilute Acid | * | $$ |
| Notched impact strength | 5.0–6.0 | Kj/m² | Vestolit | Dilute Alkalis | *** | |
| Linear coefficient of expansion | 70–110 | x 10⁶ | DuPont | Oils and Greases | **** | |
| Max cont use temp | 80–120 | °C | BASF | Aliphatic Hydrocarbons | **** | |
| Specific gravity | 1.13 | | DSM | Aromatic Hydrocarbons | **** | |
| | | | | Halogenated Hydrocarbons | *** variable | |
| | | | | Alcohols | * | |

**KEY**   * poor   ** moderate   *** good   **** very good

| Name | Trade names | Applications | Properties |
|------|-------------|--------------|------------|
| **Polyacetals POM** | **Delrin® Kematal** | **Business mechanical parts, small pressure vessels, aerosol valves, coil formers, clock and watch parts, nuclear engineering components, plumbing systems, shoe components** | **Rigid, translucent, tough, spring-like qualities, good stress relaxation resistance, good wear and electrical properties, resistant to creep and organic solvents** |
| **Polycarbonate PC** | **Calibre Lexan Makrolon Xantar** | **Compact discs, riot shields, vandal-proof glazing, baby feeding bottles, safety helmets, headlamp lenses, capacitors** | **Rigid, transparent, outstanding impact resistance (to -150°C), good weather resistance, dimensional stability, dielectric properties, resistant to flame** |
| **Polyesters (Thermoplastic) PETP, PBT, PET** | **Beetle Melinar Rynite Mylar Arnite** | **Carbonated drink bottles, business mechanical parts, synthetic fibers, video and audio tape, microwave utensils** | **Rigid, clear, extremely tough, good creep and fatigue resistance, wide-range temperature resistance (-40°C to 200°C), does not flow on heating** |
| **Polyethylene (High Density) HDPE** | **Hostalen Lacqtene Lupolen Rigidex Stamylan** | **Chemical drums, Jerry cans, toys, picnic ware, household and kitchenware, cable insulation, carrier bags, food wrapping material** | **Flexible, translucent/waxy, weatherproof, good low-temperature toughness (to -60°C), easy to process using most methods, low cost, good chemical resistance** |
| **Polyethylene (Low Density) LDPE, LLDPE** | **BP Polyethylene Dowlex Eltex** | **Squeeze bottles, toys, carrier bags, high frequency insulation, chemical tank linings, heavy-duty sacks, general packaging, gas and water pipes** | **Semi-rigid, translucent, very tough, weatherproof, good chemical resistance, low water absorption, easily processed using most methods, low cost** |
| **Stamylan PP PP** | **Hostalen Moplen Novolen Stamylan PP** | **Sterilizable hospital ware, ropes, car battery cases, chair shells, integral-molded hinges, packaging films, electric kettles, car bumpers and interior trim components, video cassette cases** | **Semi-rigid, translucent, good chemical resistance, tough, good fatigue resistance, integral hinge** |
| **Polystyrene (General Purpose) PS** | **BP Polystyrene Lacqrene Polystyrol Styron P** | **Toys and novelties, rigid packaging, refrigerator trays and boxes, cosmetic packs and costume jewelry, lighting diffusers, audio cassette and CD cases** | **Brittle, rigid, transparent, low shrinkage, low cost, excellent X-ray resistance, free from odor and taste, easy to process** |
| **Polystyrene (High Impact) HIPS** | **BP Polystyrene Lacqrene Polystyrol Styron** | **Yogurt pots, refrigerator linings, vending cups, bathroom cabinets, toilet seats and tanks, closures, instrument control knobs** | **Hard, rigid, translucent, impact strength up to 7 x GPPS** |

| Physical Properties | | | Producer | Resistance to Chemicals | | Cost |
|---|---|---|---|---|---|---|
| Tensile modulas | 3.4 | N/mm² | DuPont | Dilute Acid | * | $$ |
| Notched impact strength | 5.5–12 | Kj/m² | Ticona | Dilute Alkalis | **** | |
| Linear coefficient of expansion | 110 | x 10⁶ | | Oils and Greases | *** variable | |
| Max cont use temp | 90 | °C | | Aliphatic Hydrocarbons | **** | |
| Specific gravity | 1.41 | | | Aromatic Hydrocarbons | *** variable | |
| | | | | Halogenated Hydrocarbons | ***** | |
| Tensile modulas | 2.4 | N/mm² | Dow | Dilute Acid | *** | $$ |
| Notched impact strength | 60–80 | Kj/m² | GE Plastics | Dilute Alkalis | *** | |
| Linear coefficient of expansion | 67 | x 10⁶ | Bayer | Oils and Greases | **** | |
| Max cont use temp | 125 | °C | DSM | Aliphatic Hydrocarbons | ** | |
| Specific gravity | 1.2 | | | Aromatic Hydrocarbons | * | |
| | | | | Halogenated Hydrocarbons | * | |
| | | | | Alcohols | N/A | |
| Tensile modulas | 2.5 | N/mm² | BIP | Dilute Acid | **** | $$ |
| Notched impact strength | 1.5–3.5 | Kj/m² | DuPont | Dilute Alkalis | ** | |
| Linear coefficient of expansion | 70 | x 10⁶ | DuPont | Oils and Greases | **** | |
| Max cont use temp | 70 | °C | DuPont | Aliphatic Hydrocarbons | **** | |
| Specific gravity | 1.37 | | DSM | Aromatic Hydrocarbons | ** | |
| | | | | Halogenated Hydrocarbons | ** | |
| | | | | Alcohols | **** | |
| Tensile modulas | 0.20–0.40 | N/mm² | Hoechst | Dilute Acid | **** | $ |
| Notched impact strength | no break | Kj/m² | Atochem | Dilute Alkalis | **** | |
| Linear coefficient of expansion | 100–220 | x 10⁶ | BASF | Oils and Greases | **variable | |
| Max cont use temp | 65 | °C | BP Chemicals | Aliphatic Hydrocarbons | * | |
| Specific gravity | 0.944–0.965 | | HD DSM | Aromatic Hydrocarbons | * | |
| | | | | Halogenated Hydrocarbons | * | |
| | | | | Alcohols | | |
| Tensile modulas | 0.20–0.40 | N/mm² | BP Chemicals | Dilute Acid | **** | $ |
| Notched impact strength | no break | Kj/m² | Dow | Dilute Alkalis | **** | |
| Linear coefficient of expansion | 100–220 | x 10⁶ | Solvay Chemical | Oils and Greases | **variable | |
| Max cont use temp | 65 | °C | | Aliphatic Hydrocarbons | * | |
| Specific gravity | 0.917–0.930 | | | Aromatic Hydrocarbons | * | |
| | | | | Halogenated Hydrocarbons | * | |
| | | | | Alcohols | **** | |
| Tensile modulas | 0.95–1.30 | N/mm² | Targor | Dilute Acid | **** | $ |
| Notched impact strength | 3.0–30.0 | Kj/m² | Montell | Dilute Alkalis | **** | |
| Linear coefficient of expansion | 100–150 | x 10⁶ | BASF | Oils and Greases | **variable | |
| Max cont use temp | 80 | °C | DSM | Aliphatic Hydrocarbons | * | |
| Specific gravity | 0.905 | | | Aromatic Hydrocarbons | * | |
| | | | | Halogenated Hydrocarbons | * | |
| | | | | Alcohols | **** | |
| Tensile modulas | 2.30–3.60 | N/mm² | BP Chemicals | Dilute Acid | *** variable | $ |
| Notched impact strength | 2.0–2.5 | Kj/m² | Atochem | Dilute Alkalis | **** | |
| Linear coefficient of expansion | 80 | x 10⁶ | BASF | Oils and Greases | *** variable | |
| Max cont use temp | 70–85 | °C | Dow | Aliphatic Hydrocarbons | **** | |
| Specific gravity | | 1.05 | | Aromatic Hydrocarbons | * | |
| | | | | Halogenated Hydrocarbons | * | |
| | | | | Alcohols | ** variable | |
| Tensile modulas | 2.20–2.70 | N/mm² | BP Chemicals | Dilute Acid | ** | $ |
| Notched impact strength | 10.0–20.0 | Kj/m² | Atochem | Dilute Alkalis | **** | |
| Linear coefficient of expansion | 80 | x 10⁶ | BASF | Oils and Greases | ** | |
| Max cont use temp | 60–80 | °C | Dow | Aliphatic Hydrocarbons | **** | |
| Specific gravity | 1.03–1.06 | | | Aromatic Hydrocarbons | * | |
| | | | | Halogenated Hydrocarbons | * | |
| | | | | Alcohols | * variable | |

KEY   * poor   ** moderate   *** good   **** very good

| Name | Trade names | Applications | Properties |
|---|---|---|---|
| Polysulphone (Family) PES, PEEK | Udel Ultrason Victrex PEEK | High- and low- temperature applications, microwave grills, electro/cryo surgical tools, aerospace batteries, nuclear reactor components | Outstanding oxidative stability at high temperature (-200°C to +300°C), transparent, rigid, high cost, requires specialized processing |
| Polyvinyl Chloride PVC | Solvic Evipol Norvinyl Lacovyl | Window frames, drainpipes, roofing sheets, cable and wire insulation, floor tiles, hosepipes, stationery covers, fashion footware, cling film, leather cloth | Rigid or flexible, clear, durable, weatherproof, flame-resistant, good impact strength, good electrical insulation properties, limited low-temperature performance |
| Polyurethane (Thermoplastic) PU Thermosets | | Soles and heels for sports shoes, hammer heads, seals, gaskets, skateboard wheels, synthetic leather fabrics, silent running gear | Flexible, clear, elastic, wear-resistant, impermeable |
| THERMOSET PLASTICS Epoxies EP | Araldite Crystic Epicote | Adhesives, coatings, encapsulation, electrical components, cardiac pacemakers, aerospace applications | Rigid, clear, very tough, chemical resistant, good adhesion properties, low curing, low shrinkage |
| Melamines/ Ure (Aminos) MF, UF | Beetle Scarab | Decorative laminates, lighting fixtures, dinnerware, heavy-duty electrical equipment, laminating resins, surface coatings, bottle caps, toilet seats | Hard, opaque, tough, scratch-resistant, self-extinguishing, free from taint and odor, wide color range, resistance to detergents and dry cleaning solvents |
| Phenolics PF | Cellobond | Ashtrays, lamp holders, bottle caps, saucepan handles, domestic plugs and switches, welding tongs, and electrical iron parts | Hard, brittle, opaque, good electrical and heat resistance, resistant to deformation under load, low cost, resistant to most acids |
| Polyester (unsaturated) SMC, DMC,GRP | Beetle Crystic Synoject | Boat hulls, building panels, lorry cabs, compressor housing, embedding, coating | Rigid, clear, chemical-resistant, high strength, low creep, good electrical properties, low-temperature impact resistance, low cost |
| Polyurethane (cast elastomers) EP | | Printing rollers, solid tyres, wheels, shoe heels, car bumpers, (particularly suited to low-quantity production runs) | Elastic, abrasion- and chemical-resistant, impervious to gases, can be produced in a wide range of hardnesses |

| Physical Properties | | | Producer | Resistance to Chemicals | | Cost |
|---|---|---|---|---|---|---|
| Tensile modulas | 2.10–2.40 | N/mm$^2$ | Amoco | Dilute Acid | **** | $$$ |
| Notched impact strength | 40.0–no break Kj/m$^2$ | | BASF | Dilute Alkalis | **** | |
| Linear coefficient of expansion | 45–83 | x 10$^6$ | Victrex | Oils and Greases | **** | |
| Max cont use temp | 160–250 | °C | | Aliphatic Hydrocarbons | ** variable | |
| Specific gravity | 1.24–1.37 | | | Aromatic Hydrocarbons | * | |
| | | | | Halogenated Hydrocarbons | * | |
| | | | | Alcohols | **** | |
| Tensile modulas | 2.6 | N/mm$^2$ | Solvay Chemical | Dilute Acid | **** | $ |
| Notched impact strength | 2.0–45 | Kj/m$^2$ | EVC | Dilute Alkalis | **** | |
| Linear coefficient of expansion | 80 | x 10$^6$ | Hydro Polymers | Oils and Greases | *** variable | |
| Max cont use temp | 60 | °C | Elf Atochem | Aliphatic Hydrocarbons | **** | |
| Specific gravity | 1.38 | | | Aromatic Hydrocarbons | * | |
| | | | | Halogenated Hydrocarbons | ** variable | |
| | | | | Alcohols | *** variable | |
| Tensile modulas | n/a | N/mm$^2$ | | Dilute Acid | n/a | $$ |
| Notched impact strength | n/a | Kj/m$^2$ | | Dilute Alkalis | n/a | |
| Linear coefficient of expansion | n/a | x 10$^6$ | | Oils and Greases | n/a | |
| Max cont use temp | n/a | °C | | Aliphatic Hydrocarbons | n/a | |
| Specific gravity | | n/a | | Aromatic Hydrocarbons | n/a | |
| | | | | Halogenated Hydrocarbons | n/a | |
| | | | | Alcohols | n/a | |
| Tensile modulas | n/a | N/mm$^2$ | Ciba Geigy | Dilute Acid | n/a | $$$ |
| Notched impact strength | n/a | Kj/m$^2$ | Scott Bader | Dilute Alkalis | n/a | |
| Linear coefficient of expansion | n/a | x 10$^6$ | Shell | Oils and Greases | n/a | |
| Max cont use temp | n/a | °C | | Aliphatic Hydrocarbons | n/a | |
| Specific gravity | | n/a | | Aromatic Hydrocarbons | n/a | |
| | | | | Halogenated Hydrocarbons | n/a | |
| | | | | Alcohols | n/a | |
| Tensile modulas | n/a | N/mm$^2$ | BIP Chemicals | Dilute Acid | n/a | $ |
| Notched impact strength | n/a | Kj/m$^2$ | BIP Chemicals | Dilute Alkalis | n/a | |
| Linear coefficient of expansion | n/a | x 10$^6$ | | Oils and Greases | n/a | |
| Max cont use temp | n/a | °C | | Aliphatic Hydrocarbons | n/a | |
| Specific gravity | | n/a | | Aromatic Hydrocarbons | n/a | |
| | | | | Halogenated Hydrocarbons | n/a | |
| | | | | Alcohols | n/a | |
| Tensile modulas | n/a | N/mm$^2$ | BP Chemicals | Dilute Acid | n/a | $$ |
| Notched impact strength | n/a | Kj/m$^2$ | | Dilute Alkalis | n/a | |
| Linear coefficient of expansion | n/a | x 10$^6$ | | Oils and Greases | n/a | |
| Max cont use temp | n/a | °C | | Aliphatic Hydrocarbons | n/a | |
| Specific gravity | | n/a | | Aromatic Hydrocarbons | n/a | |
| | | | | Halogenated Hydrocarbons | n/a | |
| | | | | Alcohols | n/a | |
| Tensile modulas | n/a | N/mm$^2$ | BIP Chemicals | Dilute Acid | n/a | $ |
| Notched impact strength | n/a | Kj/m$^2$ | Scott Bader | Dilute Alkalis | n/a | |
| Linear coefficient of expansion | n/a | x 10$^6$ | Cray Valley | Oils and Greases | n/a | |
| Max cont use temp | n/a | °C | | Aliphatic Hydrocarbons | n/a | |
| Specific gravity | | n/a | | Aromatic Hydrocarbons | n/a | |
| | | | | Halogenated Hydrocarbons | n/a | |
| | | | | Alcohols | n/a | |
| Tensile modulas | n/a | N/mm$^2$ | ICI | Dilute Acid | n/a | $$ |
| Notched impact strength | n/a | Kj/m$^2$ | Shell | Dilute Alkalis | n/a | |
| Linear coefficient of expansion | n/a | x 10$^6$ | Dow | Oils and Greases | n/a | |
| Max cont use temp | n/a | °C | | Aliphatic Hydrocarbons | n/a | |
| Specific gravity | | n/a | | Aromatic Hydrocarbons | n/a | |
| | | | | Halogenated Hydrocarbons | n/a | |
| | | | | Alcohols | n/a | |

KEY   * poor   ** moderate   *** good   **** very good

Glossary

# 150

| | |
|---|---|
| Additives | A wide range of substances that help in the processing of parts or in the physical and chemical properties of a final product. The additives are added to the basic resins by the resin supplier before being supplied to the production plant. Examples of additives include UV stabilizers, antibacterial additives, flame retarders, dyes and pigments, photochromics, reinforcing fibers, and plasticizers. |
| Blends | Blends can be used to tailor-make plastics with specific characteristics that cannot be achieved by a single polymer. They are a physical blend of two or more polymers to form materials with a combination of characteristics of both materials. Typical and common blends include: ABS/PC, ABS/polyamide, and PC/PP PVC/ABS. Blends are an additional form of tailoring polymers to those created by co-polymerization, and differ from co-polymers in that they are physical mixtures, not chemical. |
| Commodity plastics | Another way of dividing plastics is by categorizing them as either engineering plastics or commodity plastics. Commodity plastics have relatively low physical properties and are commonly used in the production of everyday low-cost products. This classification group includes vinyls, polyolefins and styrenes. |
| Co-polymers | The mixing of two or three compatible monomers, in order to form a new chemical compound which can be used to create a material that has a combination of the qualities of both monomers. This differs from a blend in that they are not physical but chemical mixtures. |
| Elasticity | The amount a material recovers to its original shape and size after it has been deformed. This is different to the testing of plastic behavior, which describes the way a material stretches and does not return to its original shape or size. |
| Elastomers | Elastomers are rubber-like materials but with far more processing potential. They can be processed in the same way as thermosetting materials. Elastomers may feel like rubbers but technically differ by their ability to return to their original length once they have been deformed, rubber being able to return to its original shape more quickly and easily. |
| Engineering plastics | There are a number of ways of classifying plastics: thermoplastic/thermoset, amorphous/crystalline. Paired with commodity plastics, engineering plastics are another way of categorizing plastics. They are generally a much higher cost with superior physical, chemical, and thermal characteristics and used in applications with demanding environments. They include acetals, acrylics, polyamides, and polycarbonates. |
| Fillers | Fibrous materials like glass and carbon which give enhanced mechanical properties like stiffness. Non-fibrous materials fillers such as hollow spheres, can be used to reduce the overall weight of a part. |
| Hardness | The ability of a material to withstand indentation and scratching. The most common tests are the Rockwell and Durometer tests, which are graded in Shore hardness from Shore A soft to Shore D hard. Examples of hard plastics include melamine, urea and phenolic formaldehydes, and PET. Low-density polyethylene and elastomers are examples of soft plastics. |
| Impact resistance | A material's ability to absorb energy. The final product is determined also by shape, thickness, and temperature. The Izod test for strength involves a sample of material being clamped to a base while a weighted pendulum is allowed to swing over a raised area of the sample, to see at what point the sample would snap. |
| Monomers | The individual molecules which, when joined together, form a polymer chain. |
| Plastic | The true definition of plastic does not describe a specific material but how a material acts. In common language, polymers are known as plastic due to the way they behave physically i.e. their shape can be easily changed. |
| Polymer | A flexible, long chain of monomer molecules which display different characteristics according to the chemistry of the monomers and the size and shape of the molecules. |
| Polyolefins | This important group of polymers is made up of polyethylenes and polypropylene. Polyolefins are the largest produced plastics in the world, accounting for 45% of plastic production. Together with vinyls and styrenes, polyolefins are classified as commodity plastics. |

| Resins | Generally used to describe the basic polymerized material e.g. polystyrene, ABS, which can also be described as polymers. |
|---|---|
| Tensile strength | The maximum pulling strain that can be applied to a material before it fractures. |
| Thermoplastic | Another major classification type for plastics. A material that by the action of heat can be softened, melted, and re-formed without any change in properties. This means that off-cuts and scrap from manufacturing processes can be re-ground and re-used, and products made from thermoplastics can be easily recycled. The shape of thermoplastic's molecules is linear, allowing them to move easily under heat and pressure. |
| Thermoset plastics | One of the major ways of classifying plastics. Thermosetting plastics do not soften when heated and cannot be re-used. Due to this characteristic they do not have the same processability of thermoplastics. As opposed to thermoplastics, their molecules form a cross-linked network that limits movement within the chains. |

# Glossary

| Abbreviations | ABS | Acrylonitrile-Butadiene-Styrene | PES | Poly (Ether Sulphone) |
|---|---|---|---|---|
| | ASA | Acrylonitrilelstyrene-Acrylate | PET | Polyethylene Terephthalate |
| | ACS | Acrylonitrile Styrene | PI | Polyimides |
| | AES | Acrylonitrile Styrene/EP (D) M Rubber | PF | Phenol-Formaldehyde (Phenolics) |
| | BMC | Bulk-Molded Compound | PMMA | Polymethyl Methacrylate (Acrylic) |
| | CA | Cellulose Acetate | POM | Polyoxymethylene (Polyacetal) |
| | CAP | Cellulose Acetate Propionate | PP | Polypropylene |
| | DMC | Dough-Molding Compound | PPE | Poly (Phenylene Ether) |
| | EETPE | Copolyester Ether Thermoplastic Elastomer | PS | Polystyrene |
| | EP | Epoxy | PSU | Polysulphone |
| | EVA | Ethylene Vinyl Acetate | PTFE | Polytetrafluoroethylene |
| | HDPE | High-Density Polyethylene | PU | Polyurethane |
| | HIPS | High-Impact Polystyrene | PVC | Poly (Vinyl Chloride) |
| | LDPE | Low-Density Polyethylene | PVC/PVC | Plasticized Poly (Vinyl Chloride) |
| | MF | Melamine Formaldehyde | SAN | Styrenelacrylonitrile |
| | OTPE | Olefinic Thermoplastic Elastomer | SB | Styrene Butadiene |
| | PA | Polyamide (Nylon) | SBS | Styrenelbutadiene-Styrene Block Co-polymer |
| | PBT | Poly (Butylene Terepthalate) | SI | Silicone |
| | PC | Polycarbonate | TPU | Thermoplastic Polyurethane |
| | PE | Polyethylene | TPO | Thermoplastic Polyolefin |
| | PEEK | Polyetheretherketone | UP | Unsaturated Polyester |

## Trade Organizations

www.americanplasticscouncil.org

**The American plastics council (APC) is a major trade organization for the US plastics industry. APC works to promote the benefits of plastics and the plastics industry. Lots of relevant information on anything you need to know about plastics, including news, education, and information about health and environment issues.**

www.plasticseurope.org

**The Association of Plastics Manufacturers in Europe (APME) is the voice of the plastics manufacturing industry in Europe, representing more than 40 companies that in turn stand for over 90% of the polymer production of Western Europe.**

www.bpf.co.uk

**The British Plastics Federation is the trade organisation representing the British plastics industry.**

www.pras.com

**The Web site of the Plastics and Rubber Advisory Service. Gives online help with finding manufacturers and suppliers in the UK.**

www.polymer-age.co.uk

**Latest news from the British Plastics and Rubber industry, with up-to-date resin prices.**

www.materials.org.uk

**The Institute of Materials serves the international materials community through its wide range of learned society activities and by acting as the professional body for material scientists and engineers.**

www.epa.gov

**The webpage of the Environmental Protection Agency contains information and guidelines on numerous topics, such as the Clean Air Act, Clean Water Act, hazardous waste, global warming, and health issues.**

spmp.sgbd.com

**Webpage for the Association of French Plastics Manufacturers—Syndicat des Producteurs de Matières Plastiques.**

www.sampe.org

**The Society for the Advancement of Material and Process Engineering provides information about new materials and processes via technical forums, publications, and books.**

www.socplas.org

**The webpage of the Society of Plastics Industry (SPI), founded in 1937. The plastics industry is the fourth largest manufacturing industry in the United States, and the 1,600 members of the SPI represent the entire plastics industry supply chain, including processors, machinery and equipment manufacturers, and raw material suppliers.**

www.4spe.org

**The webpage of the Society of Plastics Engineers.**

www.plasticsinstitute.org

**The Plastics Institute of America is a not-for-profit organization, committed to plastics research and education at all levels.**

npcm.plastics.com

**The webpage of the National Plastics Center and Museum presents the history of plastics from 1824 to the present day. Find out about blood and sawdust, shellac and Bakelite, Bandalasta, and Barbie. Ideal for designers, collectors, students, and anyone else who is interested in the industrial and cultural history of plastics.**

www.deutsches-kunststoff-museum.de

**The webpage of the German Plastics Museum.**

www.plastics-car.com

**The Automotive Learning Center is a joint project between the APC and USCAR, and it covers a broad spectrum of issues relating to the use of plastics in cars.**

www.plasticbag.com

**Webpage for the Film and Bag Federation, with information and a forum related to the plastic bag and film industry.**

www.rigidplasticpackaging.org

**Webpage for the Rigid Plastic Packaging Institute with information about efficiency and productivity in the plastics packaging industry.**

www.loosefillpackaging.com

**The Plastics Loose Fill Council was founded to promote and implement the original use and subsequent recovery, reuse, and recycling of polystyrene loose fill.**

www.flexpack.org

**The Flexible Packaging Association deals with issues such as the environment, efficiency, and productivity in the plastics industry.**

www.fpi.org

**The Foodservice and Packaging Institute, Inc. is a trade organization for the suppliers and manufacturers of food packaging products, and the foodservice operators that use these products.**

www.plasticulture.org

**The webpage of the American Society for Plasticulture is dedicated to information about plastics and agriculture.**

www.fibersource.com

**The webpage of the American Fiber Manufacturers Association offers comprehensive information on plastics fibers, ranging from classic rayon and nylon to newer varieties such as corn-based PLA.**

# Types of plastics

www.pfa.org

**The webpage of the Polyurethane Foam Association contains links to its members' presentations of the material and a FAQ section.**

www.polyurethane.org

**The webpage of the Alliance for the Polyurethanes Industry.**

www.vinylinfo.org

**The webpage of the Vinyl Institute.**

www.vinyl.org

**Lots of information about vinyls.**

www.geplastics.com/resins/materials/cycolac.html

**Useful information about ABS thermoplastic resin.**

www.geplastics.com/resins/materials/lexan.html

**Information about polycarbonate, PC.**

www.dow.com/styron/index.htm

**Useful resource for polystyrene, PS.**

www.dow.com/polyethylene/index.htm

**General information about polyethylene, PE.**

www.dow.com/polypro/index.htm

**Some information about polypropylene, PP.**

www.novatecplastics.com/

**Information about polyvinyl chloride, PVC.**

www.oxyvinyls.com

**Another resource on PVC.**

www.polystyrene.org

**The webpage of the Polystyrene Packaging Council.**

www.epsmolders.org

**Webpage for the Expanded Polystyrene (EPS) Molders Association.**

www.fluoropolymers.uk.com

**General information about fluoropolymers and fluoroelastomers.**

www.siliconesolutions.com

**Silicone Solutions is a consulting and manufacturing firm with 30 years experience of silicone.**

# wwwhere.else

## Experts

www.apgate.com

The Applegate Directory for industry and technology in the UK and Ireland has information about more than 16,000 companies, and receives more than 20 million page views per year. This is the leading directory for the electronics, engineering, and plastics and rubber industry sector in the UK.

www.polymer-search.com

PSI is a free internet search engine dedicated to the polymer industries. Only sites that offer considerable content directly related to rubber, plastics, or adhesives are indexed.

www.plasticscommerce.com/

Launched in October 1999, plasticscommerce.com is a global portal for promoting trade among plastics companies with their suppliers and buyers from around the world. The database contains the details of companies from the entire supply chain—from suppliers of raw materials and equipment, to service providers of all kinds of work, including mold-making, assembly, fabricating, and finishing.

www.rapra.com

Rapra Technology is Europe's leading independent plastics and rubber consultancy. Rapra provides comprehensive services to the polymer industry and the industries that use plastics and rubber in any component, product, or production process.

www.design-council.org.uk/materials

The webpage of the Design Council contains articles with information on materials for designers and businesses, organised according to subject.

www.100percentmaterials.co.uk

100%Materials is a part of 100%Design, a trade show that annually attracts some 35,000 visitors to London's Earls Court exhibition centre. On this webpage you will a materials database that contains over 300 entries in five categories—plastic, metal, wood, ceramics, and glass.

www.matweb.com

MatWeb has detailed information of 20,000 materials including metals, polymers, ceramics, and other engineering materials.

www.ecomplastics.com

Ridout Plastics/Clear Presentations has served the world with plastic materials and manufacturing services for 87 years.

www.tangram.co.uk

Consulting and engineering for plastics, Tangram Technology provides high-quality training, technical writing, change management, product design, and field services to all areas of the plastic products industry.

www.plastics.com

This webpage has general information about plastics and links to manufacturers etc.

www.finishingsearch.com

A search engine for paint, powder-coating, and other finishing for plastics.

www.plasticsnet.com

Easy-to-use search engine for plastic-related supplies in the US.

www.polymers-center.org

The Polymers Center of Excellence can help trim costs and improve productivity for anyone that processes, manufactures, purchases, designs or needs technical assistance with products using plastics or rubber.

www.amiplastics.com

AMI is Europe's largest market research consultancy providing research, consulting, and analytical services to the global plastics industry. AMI is also a major publisher of both commercial and technical information for the plastics industry.

www.thomasnet.com

ThomasNet is the free web service of Thomas Register, the world's most comprehensive directory of US and Canadian manufacturers, listing over 168,000 industrial product and services companies.

www.ets-corp.com

The webpage of Engineering Training Services, Inc. offers a comprehensive list of plastics trade names and acronyms, a design checklist and tools, for polymer selection.

www.modernplastics.com

Modern Plastics offers wide expertise in the field of polymers and carries a huge stock of materials.

www.performance-materials.net

Performance Materials Net is a searchable database with focus on advanced high-performance materials.

www.polymerplace.com

Design guidelines and checklists, a glossary of plastic technology terms, and articles on a wide range of polymer-related subjects.

www.packagingtoday.com

In addition to information about packaging in general, Packaging Today contains good articles on plastic materials and the history of plastics.

# Plastic Producers

www.glscorporation.com

GLS is both a custom compounder and distributor of soft, flexible thermoplastic elastomer for injection-molding and extrusion. These products are offered to designers for ergonomic, soft-touch, and flexible applications in sporting goods, housewares, hardware, packaging, etc.

www.lnp.com

Produces high-performance thermoplastic compounds, refining the effects of base resins through electrical and thermal activity, lubricity, structural strength, dimensional stability, and color accuracy.

www.eastman.com

The Eastman Chemical Company is a leading international company that produces more than 400 chemicals, fibers and plastics. Eastman is the world's largest supplier of polyester plastics for packaging, and a leading supplier of coatings for raw materials.

www.basf.com

BASF is a large manufacturer of polymer resins, coatings, and additives.

www.ashleypoly.com

Ashley Polymers has a full range of engineered resins, ranging from premium lines to economy materials.

www.nowplastics.com

NOW Plastics is a full-service company with the ability to locate, market, finance, store, and transport any kind of plastic film or packaging material in the world.

www.vink.com

VINK stocks one of the broadest assortments of semi-finished plastics in Europe, such as sheets, films, and blocks, as well as tubes and fittings.

www.novachem.com

NOVA Chemicals is an international commodity chemical manufacturer with focus on styrenics and olefins/polyolefins.

www.v-tec.com

V-Tec is a supplier of a wide variety of coatings, including anti-fog, metallic, electrostatic dissipative, anti-static, anti-glare, UV blocking, laser blocking, and photochromic.

www.solaractiveintl.com

SolarActive International makes products that change color when they are exposed to the sun.

www.davisliquidcrystals.com

Liquid Crystal Resources LLC manufactures thermochromic products that change color based on temperature.

www.distrupol.com

Distrupol is one of the leading distributors of high-quality polymer resins in Europe.

www.burallplastec.com

Burall specializes in printing and fabrication of plastic sheet materials.

www.medicalrubber.se

Medical Rubber develops and produces molded precision components to customer specifications from liquid silicone rubber and thermoplastic elastomers (TPE). The company has two divisions—health care and industrial products.

www.sdplastics.com

San Diego Plastics, Inc. is a distributor of plastic sheet, rod, tube, and film. They can supply formed and machined parts to your specifications, including phenolic sheet and Teflon tubes and fittings.

www.globalcomposites.com

Global Composites is a web portal set up to facilitate use of composite materials between the composite industries and the industries that use composite materials, such as the aeronautics, automotive, and construction industries.

www.dielectrics.com

Dielectrics Industries designs, develops, and fabricates components and finished product on a contract manufacturing basis, utilizing films, laminates, and specialized performance materials. Their products typically include RF welded bladders that are either air-, fluid-, or gel-filled.

www.dow.com

Dow Plastics offers one of the broadest ranges of thermoplastics and thermosets globally. A leading manufacturer of polyethylene, polystyrene, and polyurethane, they also supply engineering plastics such as ABS, polycarbonate, and polypropylene.

www.sealedair.com

The Sealed Air Corporation is a leading global manufacturer of materials and systems for protection, presentation, and fresh food packaging in the industrial, food, and consumer markets.

www.plaslink.com

UK-based All Plastic Part & Product Database was set up to enable designers and manufacturers to search for specific products and plastic parts, by keywords and usage categories.

www.clariant.com

The pigment and additives division of Clariant has developed more than 2,000 products, used in everything from masterbatches to printing ink.

www.natureworksllc.com

NatureWorks LLC manufactures NatureWorks® PLA resin and Ingeo™ fibers, based on compostable and annually renewable corn.

www.britishvita.com

British Vita can supply a large range of specialist polymer products, from foams and non-woven fabrics to thermoplastic sheet materials and compounds.

www.dupont.com
DuPont is one of the world's largest manufacturers of plastic materials, with a portfolio that includes Corian®, Teflon®, Kevlar®, and Tyvek®.

www.technogel.it
Technogel is a polyurethane material that is well known for its outstanding ability to absorb pressure.

www.3m.com
There is more to 3m than Post-It notes and Scotch sticky tape, it also manufactures a large range of polymer products.

www.kraiburg.de
Kraiburg is a large manufacturer of thermoplastic elastomers, TPEs.

www.lucite.com
Lucite is the maker of the famous Perspex® acrylic sheet material.

www.abet-laminati.it
Abet Laminati supplies a large range of plastic laminates, with collections such as metallic effects, fluorescent colors, and wood imitations.

www.research.philips.com
Philips has contributed to many groundbreaking technologies, including ultra-thin lithylene batteries, polymer light-emitting diodes, and anisotropic polymer gels.

www.fraunhofer.de
The German Fraunhofer Institute is one of the world's largest centers for research and development in all fields of engineering science, with 58 departments that deal with everything from functional materials and nano technology to wood research.

www.geplastics.com
GE Plastics manufactures a large number of polymer resins, pigments and additives, as well as structured products such as Lexan® sheets.

www.smile-plastics.co.uk
Smile Plastics use everything from used CDs and cellphone covers to boots and yogurt pots to make their unique multicolored sheets.

www.huntsman.com
Huntsman produces a diverse range of chemical products and plastics, including amorphous polymers, polyurethanes, and expanded polystyrene for use in permanent formwork in the construction industry.

www.bayermaterialsciencenafta.com
The webpage of the Bayer Polymers division.

# Plastics and the environment

www.plasticsresource.com
This webpage is a large resource for information on plastics and the environment, conservation, and recycling.

www.plasticsinfo.org
This webpage is dedicated to plastics and health issues.

www.recoup.org
Promotes household plastic container recycling in the UK.

www.plasticx.com
Worldwide electronic information exchange for scrap plastic recycling.

www.n6recycling.com
A webpage devoted to recycling of nylon.

www.cawalker.co.uk
C. A. Walker offers a next-day plastics waste collection service throughout the UK. The material is returned for reuse after processing.

www.opcleansweep.org
Information about Operation Clean Sweep, an initiative from within the plastics industry to reduce waste and the release of resin pellets.

www.plastics-in-elv.org
Information about separation and recycling of plastics in ELVs.

plasticsrecycling.org
Webpage for the Association of Post Consumer Plastic Recyclers, with information about plastics recycling in general, and design guidelines.

www.napcor.com
The webpage of the National Association for PET Container Resources contains information and guidelines for PET collection programs.

www.iaer.org
Webpage for the International Association of Electronics Recyclers.

www.eupc.org
European Plastics Converters embraces all sectors of the plastics converting industry, including recycling.

www.greenbuildingsolutions.org
Dedicated to sustainable and efficient architecture, with an emphasis on conservation of resources and health issues.

www.allplasticbottles.org
Guidelines for setting up a plastic bottle collection program in the local community.

www.iaer.org
Contains information about its certificates and members, as well as general information about electronics recycling.

# Thank you

Thanks and acknowledgments to Tom Dixon pp14-15; Milliken & Company p16; Cellbond Composites Ltd p17; Xavier Young photography pp18-21; Polar p22; Xavier Young photography pp23-24; Chromazone p27; Xavier Young photography pp28-29; Dupont p30; iStockphoto p31, Nick Gant pp34-35; Magis Design p35; Xavier Young photography p37; Alessi pp38-39; Carolina Herrera, New York p 40; Karim Rashid p41; Xavier Young photography p42; Plank p43; Karim Rashid pp44-45; Ron Arad p46; Ronan & Erwan Bouroullec p47; Flexplay p50; Taiseiplas p51; Xavier Young photography pp52-54; Foampartner pp56-57; Xavier Young photography pp58-60; W2 P61; Phillips p62; Xavier Young photography pp66-67; Herman Miller pp68-69; Verner Panton Estate p70; VICTORINOX p71; Solvay Plastics p72; Xavier Young photography pp73-74; Maaike Evers and Mike Simonian pp76-7;, Alessi p78; Ictrex  p79; Xavier Young photography p80; Rob Thompson pp84-85; IDEO and Rick English photography pp86-87; Xavier Young photography p88; Pandora Design p89; Xavier Young photography pp90-91; Plantic p92; Wtl-international p93; Xavier Young photography pp94-95; Hugo Jamson p96; Xavier Young photography p97; Magis Design p100; Mvg Design p101; Tom Dixon 102-103; Xavier Young photography pp104-105; Barbara Schmidt p106; Thomas Duval photography p107; Xavier Young photography pp108-109; Omlet Ltd p110; Xavier Young photography pp114-115; Karim Rashid pp116-117; Fitch pp118-119; Xavier Young photography pp120-123; Nike Inc p124; Xavier Young photography p125; Yves Béhar pp126-127.

Special thanks to: Karim Rashid for his never ending support for this series in so many ways; to April Sankey, Chris Middleton, Tony Seddon, Jane Roe, and Susan Spratt at RotoVision for being such a supportive team. To Xavier Young and his photography, who not only is a fantastic guy and fabulous photographer, but is a true partner in these books. To Daniel Liden for the inspired cover design and without whom so many things would be unachievable. To Hayley Ho who has been a savior yet again. To Dominic Cort, Oliver Newberry, Peter Li, Chris Pellegrini, Bunney Mark, Zoe Stavrou, Vaidehi Pittie for a particular materials project that I am eternally grateful. Lastly to my wife Alison and son Theo, thanks for just being there.

Index